Table of Contents

Introduction to Manga

Manga (pronounced mahn-gah) is the Japanese word for "comics," which literally translates to "whimsical pictures." It is generally used to describe comics made in Japan, but it is also loosely used to describe comics that resemble Japanese ones, even though they are not created in Japan. The four major types of manga are *shônen, shôjo, seinen*, and *jôsei*. Shônen, or boys' manga, is action-packed and usually includes sports, science fiction, or fantasy elements. Dealing with romance, comedy, and coming-of-age drama, shôjo manga is aimed at junior high and high school-aged girls. Adult male audiences read seinen manga, which offers business and crime stories, as well as historical and military dramas. And for young and middle-aged women, jôsei manga focuses on career, family, and romantic dramas. There are also manga for food enthusiasts, gamers, and other hobbyists.

Most manga is produced in Japan and translated for overseas audiences, but original manga and manga-influenced works can increasingly be found in Korea, China, France, and the United States. Discover the art of manga with the instruction in this book, produce your own manga, and become a part of the growing global manga community!

TIP

In Japan, a mangaka, or manga author, has assistants who help with details, backgrounds, and screentone. Most manga artists start off as assistants before attaining full *mangaka* status, but it is possible to gain recognition through contests and skip the apprenticeship stage. You too can become a *mangaka!*

Tools & Materials

Here are the basic materials you'll need to begin creating your own manga.

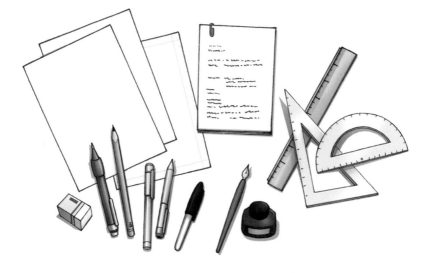

PENCILS

An HB pencil is great for beginners, but you may also want to try out the other lead types, which vary in hardness and value. Try a non-photo blue colored pencil for initial sketches, and be sure to keep your pencils sharp. Use a rubber eraser to clean up mistakes and unneeded pencil lines.

PENS

Use an ink pen if you want to ink your drawings. You can also experiment with different types of pens, such as dip, brush, and ballpoint for different effects. Use waterproof ink for more permanent results.

RULERS

To draw borders and straight lines, use a standard 12-inch ruler. Consider purchasing a triangle ruler, protractor, or stencils for various types of lines and curves. When inking, use a ruler with an inking edge for cleaner drawings.

COLORING TOOLS

Color your drawings with markers, colored pencils, or digital coloring.

PAPER

Use a sketchbook to thumbnail your ideas and start recording your own manga chronicles. It may also help to use comic layout paper with pre-printed borders. For more finished drawings, use a heavier white paper with a smooth finish, such as Bristol board.

SCREENTONE

You may want to purchase pre-printed screentone patterns to add texture and shading to your artwork. Cut out the screentone, peel off the protective backing, and place the screentone on your drawing. Next, adhere it to the paper by firmly rubbing with a burnisher.

USING DIFFERENT PENS

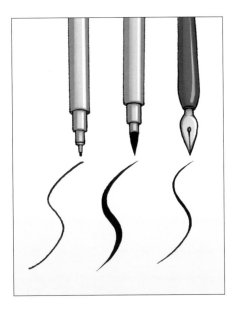

Use a fine-tipped pen for smooth, consistent lines. To emphasize elements in an image, go over them with a bold brush pen. Dip pens are fun because you can create a wide variety of line widths with just one tip, depending on pressure.

INKING EDGES

An inking edge provides a gap between the ruler and paper, preventing ink from bleeding into the paper. If you can't find beveled rulers with inking edges, make your own by taping pennies to the bottom of your ruler.

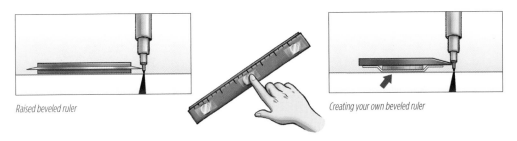

Raised beveled ruler

Creating your own beveled ruler

LIGHT BOX

A light box is a useful and generally inexpensive tool with a transparent top and a light inside. The light illuminates paper placed on top, allowing dark lines to show through for easy tracing. Simply tape your rough drawing on the surface of the light box, place a clean sheet of paper on top of your sketch, and turn on the light.

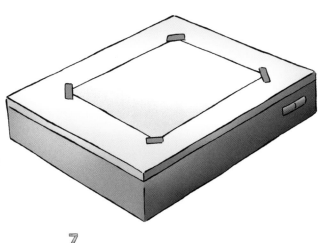

Basic Shapes

To begin, use basic shapes, such as circles, squares, and cylinders, to create your character's form. Breaking down complex drawings to basic shapes helps artists understand why certain shapes and forms move the way they do. It also helps to easily identify areas that need correction when it comes to proportion, or foreshortening, which can be complex. However, don't get caught up in the details; the idea is to learn how to build a figure from the bottom up, one step at a time.

Step 1

Start with a basic skeletal structure. Identify the head and joints with circles, and major body parts with lines that establish the pose. Establish height and proportion.

Step 2

Lay down the basic shapes by using your first line structure as a guide. Use simple shapes like circles and cylinders to flesh out your figure.

Step 3

Continue defining the details of your figure, including the clothing.

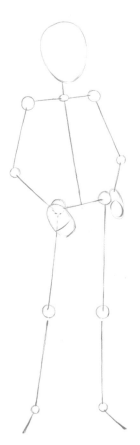
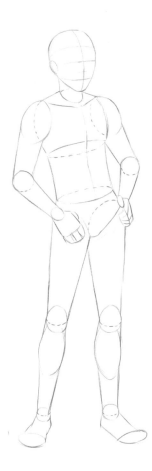
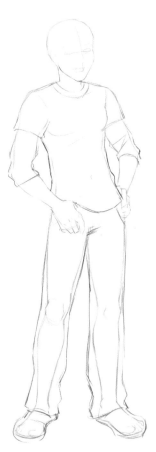

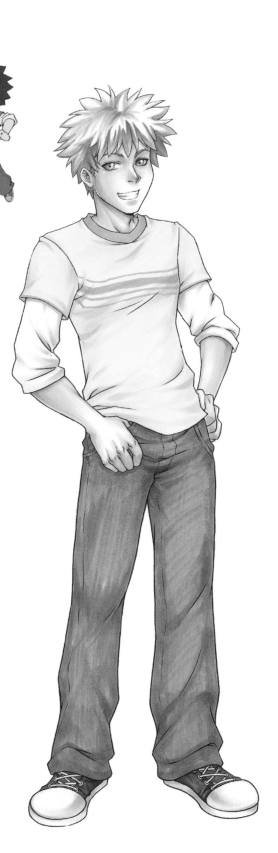

TIP

Study a few pages in your favorite manga and try deconstructing each character into basic shapes. Eventually, you will be able to deconstruct just by looking.

Step 4

Add your character's facial features, hair, and clothing details. After finalizing the details, ink the outline of your drawing.

Step 5

Add color.

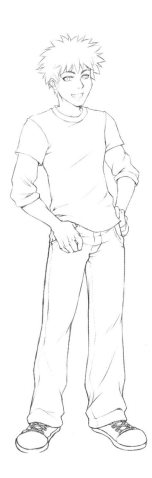

Shading

Once you have established the basic shapes and details of a drawing, you can add depth to the forms with shading. Create the illusion of three-dimensionality in a two-dimensional object with clear contrasts in value, or the relative lightness or darkness of a color or black. You can shade a drawing with pencil, ink, screentones, or any medium used to color.

Hatching

The most basic method of shading is to fill an area with hatching, which is a series of parallel strokes.

Light and Shadow

The *highlight* is the lightest value, where the light source directly strikes the object. The *light gray* area surrounds the highlight, and the *middle gray* is the actual color, without any highlights or shadows. The *cast shadow* is the shadow that the object casts onto the ground. The *form shadow* is the shadow on the object itself. *Reflected light* bounces up onto the object from the ground surface.

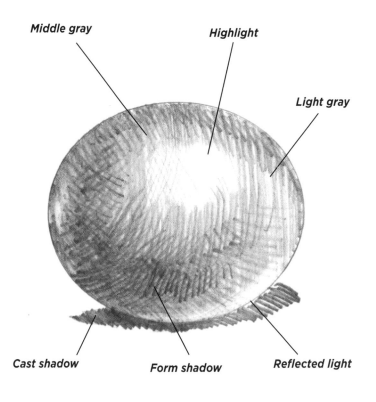

Middle gray *Highlight* *Light gray*

Cast shadow *Form shadow* *Reflected light*

Coloring

When coloring, work in layers—from the lightest colors to the darkest shadows. Be sure to make all your strokes in the same direction, and leave the brightest highlights white. Use markers to achieve a blocky coloring style common in anime. You may also try colored pencils, which work similarly to regular pencils, or digital coloring techniques for blending and various lighting effects.

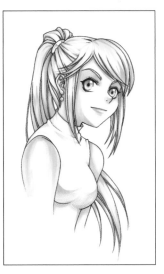

Inking

Inking is the term used for creating line art, or using a pen or other ink material to finalize a drawing. Inking will preserve your drawings. When inking, varying the line widths creates the illusion of texture and can help give depth to your drawing. You can start with a black marker, but you'll also want to experiment with different pens. Dip pens have interchangeable tips and brush pens produce bold lines. Try ink pens for more consistent ink flow or ballpoint pens for softer, subtle line art.

Dip Pen

Brush Pen

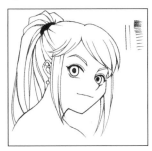

Ink Pen

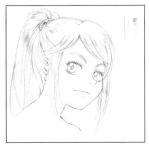

Ballpoint Pen

Poses & Perspective

LINES OF ACTION

Different types of lines in a composition, such as curves or diagonals, can convey action and movement. The line of action is a specific, imaginary line that extends through the main portion of a figure, usually following the direction of the figure's spine. The line of action, along with two smaller lines—the shoulder line and the hip line—define a figure's pose. It is helpful to plan out the facial feature guidelines on the head and the four major joints in your initial sketch. This will allow you to quickly and efficiently establish a character's pose.

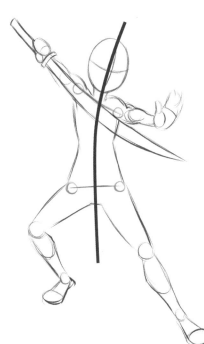

Line of Action

The blue line of action mimics the spine and the tilt of the neck and head. Defining the line of action first will help you figure out the rest of the pose since all body parts follow the orientation of the trunk and spine.

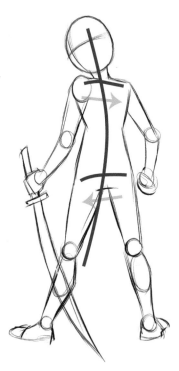

Shoulder and Hip Lines

The shoulder and hip lines intersect the line of action and define the position and origin of movement for the limbs. Establishing these lines with the line of action offers the base for how far the limbs can move in any direction.

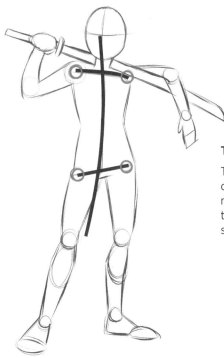

Tilting Lines

Tilt the shoulder and hip lines in opposite directions to achieve more interesting and natural-looking poses. This adds a subtle dynamic to the pose when compared to a character whose shoulders and hips are parallel to the ground.

PERSPECTIVE

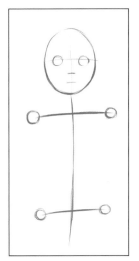

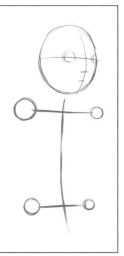

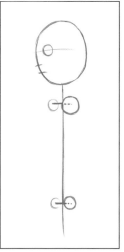

Front View
From the front view, the hip and shoulder lines are parallel, and the four major joints are equal in size. In males, the shoulder line is generally longer than the hip line since males tend to have broader shoulders than females.

3/4 View
This figure is turned at a three-quarter angle. Notice that the shoulder and hip joints (red circles) closest to the viewer are larger than the joints on the farther side.

Side View
The side view is often difficult to draw, because only the line of action and joints closest to the viewer are visible. Try drawing through the image and placing all lines and joints. Your final drawing will appear more three-dimensional if you can visualize the entire structure.

Heads

Some manga artists draw in a more realistic style with facial proportions that are closer to the real human form; other artists choose to draw in a more stylized way with bigger eyes or longer foreheads. Once you understand the fundamental shapes and proportions of a typical realistic face and its features, you can bend the rules to create more extreme or unique styles.

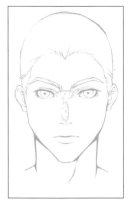

T-ZONE

A simple yet efficient way of measuring eye distance is to use the eye itself. Generally, the space between the eyes is about the length of one eye. There is a similar amount of space between the bridge and tip of the nose.

NATURALISTIC

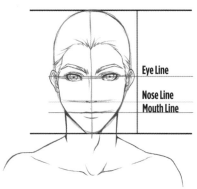

Eye Line

Nose Line
Mouth Line

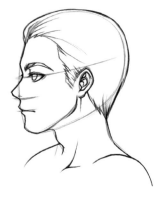

STYLIZED

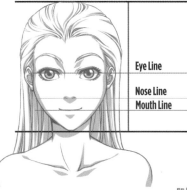

Eye Line

Nose Line
Mouth Line

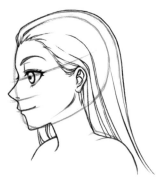

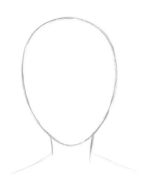
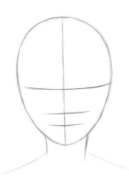
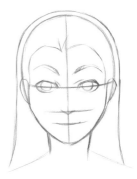

Step 1

Begin with an oval shape.

Step 2

Sketch in guidelines for the facial features—a cross for the eye line and T-zone, and shorter horizontal lines for the nose and mouth.

Step 3

Lightly sketch the eyes, ears, nose, mouth, eyebrows, and hairline.

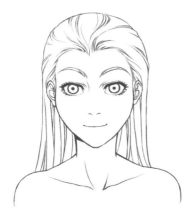

Step 4

When you are satisfied with your sketch, ink your drawing, or turn it into line art. Add final details, such as eyelashes and pupils.

Step 5

Add color. See page 11 for coloring techniques.

Hair

Curly, spiky, cropped, or straight—there are many different ways to draw hair. Some artists prefer drawing hair realistically with a lot of detail. Others prefer a stylized look and draw only contour lines that imply the hair's shape. You can also block in the hair without highlights or shading if a character has dark hair.

HAIRSTYLES AND PERSONALITY

Hair can play an important role in defining a character. For example, you may give a bubbly shôjo girl bouncy curls or a rebellious hero pointy locks. Accentuate a tough guy's angular features with close-cropped hair, a widow's peak, and sideburns.

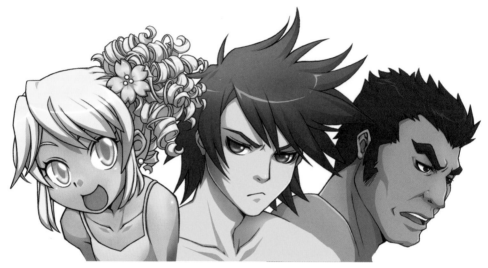

HAIR AND GRAVITY

In this illustration, the hair is transparent, so you can see how hair drapes around the head and neck. Keep in mind that gravity determines how a character's hair falls. Decide where you want to part the hair (this example shows a side part), and draw the hair hanging down from that part.

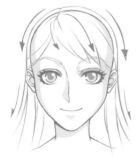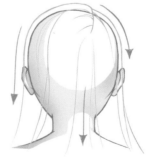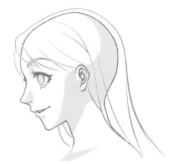

HAIR AND HEAD SHAPE

The shape of the head affects the size and direction of hair growth. Always draw hair around the shape of the head, and consider the effects of wind and gravity.

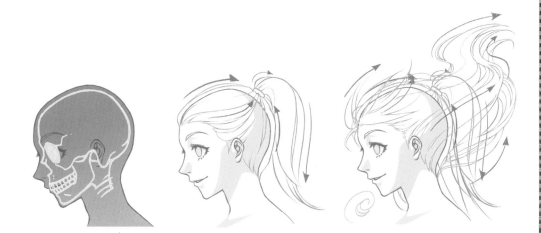

HAIR TEXTURES

It is helpful to understand how individual strands and clumps of hair behave when trying to depict various hair textures and styles. Natural hair styles will have a different shape and weight than crimped, curled, or bluntly cut hair.

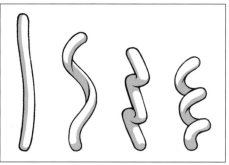

Manipulated Hair

Imagine each strand of hair as a string. When straight, it is at its maximum length. Adding a wave, crimp, or curl shrinks the strand. Remember that hair is made up of many individual strands.

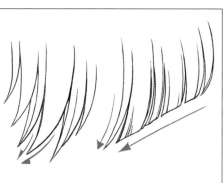

Hair Ends

In most styles, hair ends are drawn in points or clumps (far left). You also can draw hair that is cropped straight at the ends, giving it a freshly cut appearance (near left).

Facial Features

A great deal of manga storytelling occurs on a character's face where a range of emotions are displayed. Let's focus on the individual facial features and see how they all work together to bring a character to life.

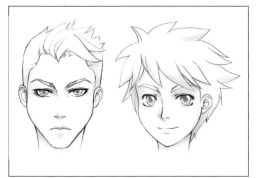

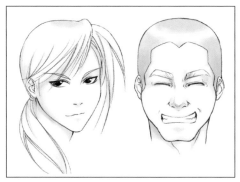

EYES

Eyes are the most expressive part of a character's face, and there are infinite ways to draw them. Above are two basic examples of different eye shapes and sizes. Notice how the eyes define the character. The male with narrow eyes could be a villain; the big, bubbly eyes could belong to a young boy in a shôjo comic. Experiment with a few different eye styles while thinking about the type of character you are trying to portray.

NOSES AND MOUTHS

Noses complete the overall symmetry of the face and add character. A nose can consist of two small dots, short lines, or an implied shadow. Males tend to have more prominent noses. Like eyes and noses, there are many ways to draw mouths—with simple lines or defined lips and dimples.

EYEBROWS

Eyebrows are also important for portraying expressions. Eyebrows are usually the same color as a character's hair. Altering the shape of the eyebrow is effective for showing emotions. For example, if both eyebrows face sharply toward the center of the face, the character might look very angry. Having them point up can show surprise or shock.

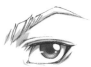

Angled

Bushy

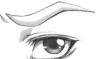

Arched

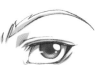

Thin, Rounded

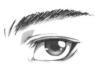

Realistic

Expressions

DRAWING EXPRESSIONS

Now put all of the facial features together to create different expressions. The character below is making a variety of extreme faces indicating happiness, sadness, embarrassment, disapproval, outrage, fear, and wickedness. Even though the expressions change, the character should maintain consistent features. Try drawing one character with different emotions for practice.

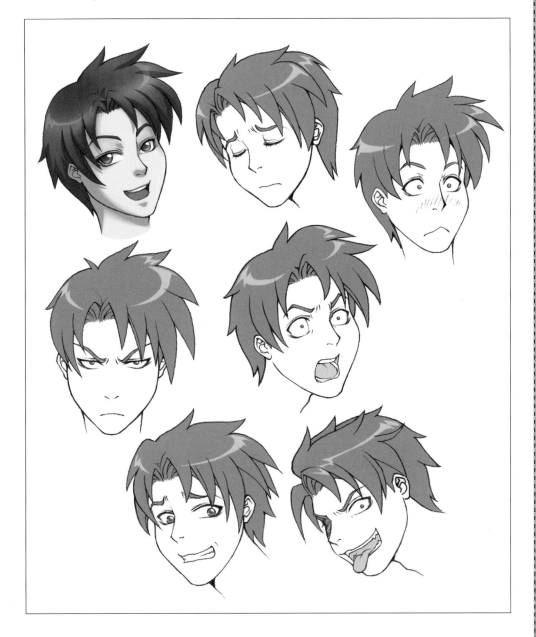

HEAD SHAPES

The shape of a character's head can reveal a lot about the character's personality. While the most common head shape is an oval, there are many other possibilities. The three basic shapes for drawing anything are the circle, square, and triangle. Experiment by combining the different shapes to create more unique and expressive head shapes.

Oval

Most general characters have oval-shaped heads.

Triangular

Sharply angled heads are good for villains.

Square

Give strong, beefy guys sturdy, square heads.

Circular

Comical characters often have circular heads.

PRACTICE HERE

Create Your Own Manga Adventure

Sometimes it's difficult to start creating your own manga because there are so many genres to choose from. If you're not sure where to begin, it may help to think about what type of manga you like to read. Take the quiz on the opposite page to discover your manga style and story ideas that may jump-start your imagination!

WHAT KIND OF OTAKU ARE YOU?

An *otaku* is a serious manga fan. Answer these questions to figure out what manga style suits you best.

1.) My favorite mangas make me
- A. Sweat
- B. Cry
- C. Laugh
- D. All of the above

2.) My favorite thing to do when I get home is
- A. Play my favorite video game—one that involves tons of action!
- B. Call or text my friends.
- C. Cook, listen to music, or work out.
- D. I love doing all of these activities. It just depends on my mood.

3.) If I had super powers, I would
- A. Lead an elite fighting squad to save the world.
- B. Prevent evil and heal wounded hearts.
- C. Win tournaments and spread my favorite activities across the world.
- D. I can't decide. There are too many things I would do!

4.) I am more of a
- A. Fighter
- B. Lover
- C. Doer
- D. All of the above

5.) My walls are plastered with
- A. Posters of all my favorite heroes.
- B. Photos of my friends and family, animal pictures, floral decorations, or cool designs.
- C. Posters of my favorite sports teams or bands.
- D. All of the above

6.) At the mall, you'd most likely find me in a(n)
- A. Electronics or game store
- B. Accessories, clothing, or pet store
- C. Music, sporting-goods, or kitchen-goods store
- D. Department store—it has everything!

7.) I can best be described as
- A. Adventurous
- B. Sentimental
- C. Enthusiastic
- D. All of the above

8.) If I was a manga character, I would be
- A. A samurai or space warrior
- B. A magical girl or star-crossed lover
- C. A talented hero
- D. Every character

Results: If you got...

Mostly A's:
You're a heroic otaku. You value friendship, perseverance, and victory, and you love adventure, martial arts, and stories that cross the universe. Throw in some robots and a few monsters, and you have the perfect manga! Consider using a ninja in your next story, or set your characters on a strange planet filled with dragons, wizards, and fantastical creatures.

Mostly B's:
You're a romantic otaku. You love falling in love and can't resist getting swept up in stories that feature magical girls, young heroes, and couples in love. Close relationships, happiness, and personal style are important to you. Try creating an epic romance set during your favorite historical period, or focus on the daily dramas all around you—but with a magical twist!

Mostly C's:
You're a hobbyist otaku. You're passionate about sports, games, performance art, and food, so stories featuring these popular pastimes are sure to get you daydreaming. For added drama, check out board game manga, or cook up a tale revolving around an extreme version of your favorite activity.

Mostly D's:
You're an eclectic otaku. You love all forms of manga and can't get enough of them. Consider adding a pet or fun animal mascot to your stories, or create quirky characters with different specialties that allow you to express all of your varied interests. The possibilities are endless!

SKETCH A MANGA ADVENTURE HERE

Dr wing M ng nd Anime Characters

The world of anime and manga is colorful, diverse, and full of endless opportunities. As anime and manga have grown in popularity, they've permeated many types of media: television series, films, video games, commercials—the list goes on. These projects will help you build an understanding of this art form.

WHAT IS MANGA?

As you know, manga is defined as comics created in Japan, or works created by Japanese artists in the Japanese language. You can find manga of any genre—action, adventure, horror, sports, history, comedy, science fiction, etc. As Manga becomes more diverse and expansive, it has given birth to identifiable sub-genres within itself!

Some artists who are not Japanese call themselves mangaka, which is the Japanese word for "manga artist." In professional comic industries, "manga" is typically reserved for comics that are produced in Japan. In the U.S., terms like "amerimanga" and "original English-language manga" (OEL) have been developed to refer to comics that have a strong manga/Japanese-comic style influence but are not produced in Japan.

As an artist, it is good to know your medium—especially if you plan to make your own comic. Do your research: Read lots of manga, and watch lots of anime. Consider it homework—really, really fun homework! The more you know, the more inspiration you will have to draw from as you begin to develop your own characters and story for the world to enjoy.

WHAT IS ANIME?

Anime (pronounced a-nee-mei) is officially defined as Japanese cartoons and animations. Anime is often derived from a manga. Some anime and manga are completely different, with different characters and story lines. Other anime may follow their manga "parents" closely. We encourage you to explore both: If you have a favorite manga, check out its anime version, and vice-versa. Consider it research!

Male Hero

Most manga adventures feature a mysterious and moody hero with a serious but honorable goal or quest. This male hero may appear cold and distant, but he embodies the values of perseverance, fellowship, and justice.

Step 1

Sketch the body with basic shapes and map out the line of action, hip and shoulder lines, and major joints. Finalize the pose, body proportions, foreshortening, and perspective to prevent troublesome revisions later on.

Step 2

Sketch the basic contours of the body and sword. Working from the head down, add basic details in the hair, face, hands, and feet.

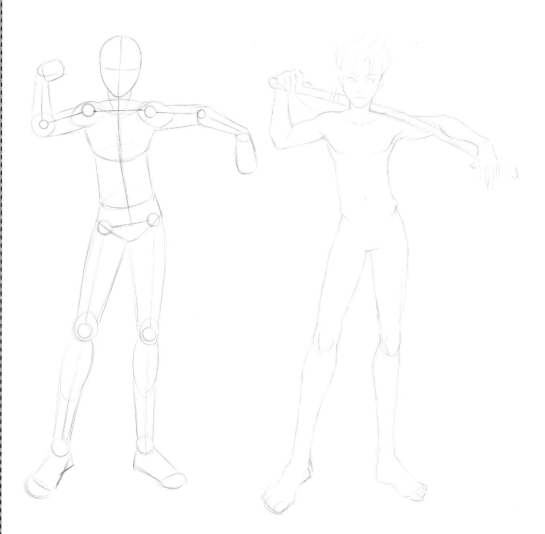

Step 3

Lightly sketch the clothes. Work in layers, drawing the shirt, coat, pants, and accessories.

Step 4

Once you have your final sketch, ink your drawing to create line art.

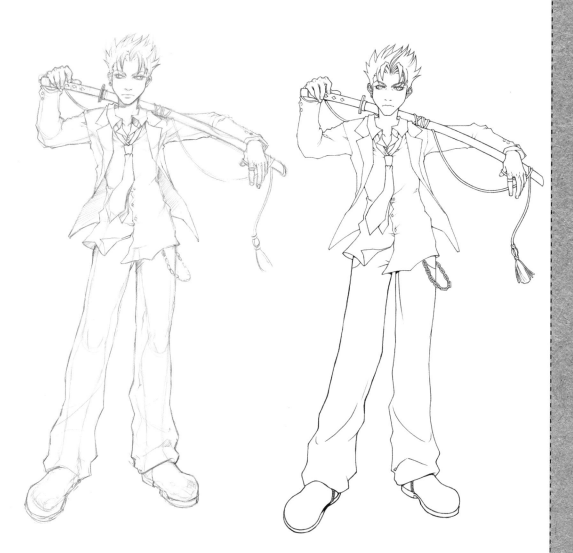

Step 5

Add color in layers. Use grays and black for the sword, jacket, pants, and shoes. Color the face, neck, and hands with flesh tones. Finally, add touches of blue for the eyes, gold in the sword, and red for the tasseled cord and necktie.

TIP

Make photocopies of your line art to practice with different styles and materials.

FINISHING TECHNIQUES

Fine details and value contrasts can bring a character to life. Not all of the details have to be drawn in the line art; shapes, depth, and details can be rendered with coloring.

Details

In the line art, the major details have been drawn in, but the nose is only represented with two small lines.

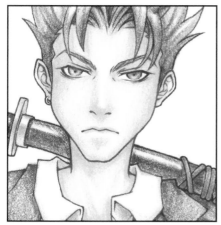

Layers

Color in layers, starting with the lightest colors and gradually building up darker colors.

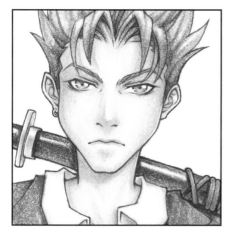

Shadows and Highlights

Create sharper contrasts by darkening shadows and brightening highlights.

Schoolgirl

Shôjo manga often revolve around the daily lives of junior-high or high-school students. This schoolgirl's main concerns involve passing her classes, finding romance, and bonding with her girlfriends. She may have hidden super powers, but that's for you, the mangaka, to decide!

Step 1

Sketch the basic shapes for this casual pose, establishing the action, shoulder, and hip lines; place the major joints; and measure out accurate body proportions.

Step 2

Draw the basic contours of the body, hair, and handbag, and add her facial features. Think about the character's personality. This classic girl next door has straight hair and wide, innocent eyes.

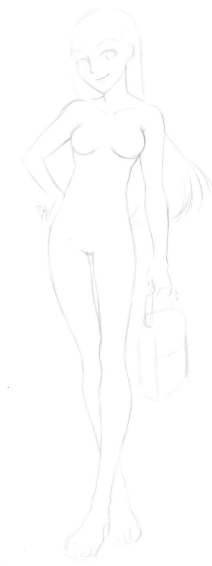

Step 3

A traditional Japanese school uniform includes a collared shirt, tie, sweater, and short pleated skirt. To complete the outfit, add accessories, such as hairpins, a watch, plush keychain, and shoes. Render your final details and textures at this stage.

Step 4

Ink the sketch, and erase unnecessary marks. Use fine, thin lines for a light, cheerful mood.

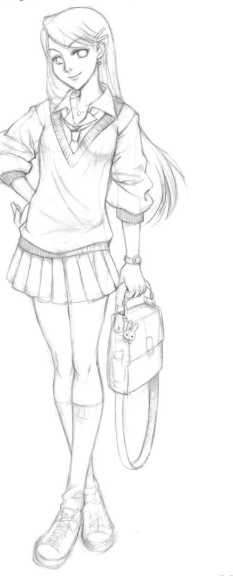

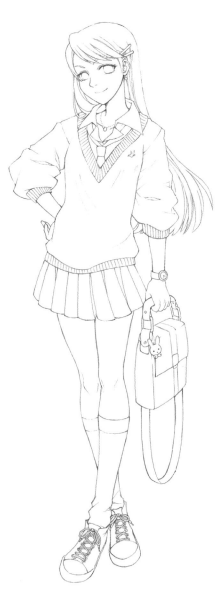

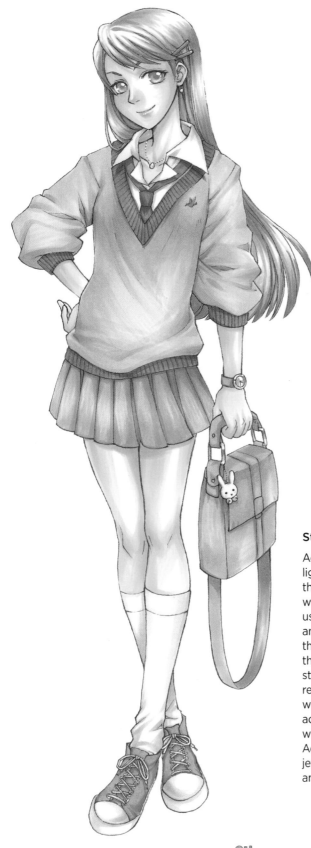

Step 5

Add color by laying down the lightest colors first; then build up the darkest areas. If you are working with markers, use light pressure. Try using a cool gray for the sweater and a warmer gray or brown for the bag. With soft strokes, capture the textures in the blue skirt and strands of brown hair. Color the tie red and add pink for the hair pins, watchband, and shoes. Finish up by adding a few key highlights with a white gel pen or white acrylic paint. Adding white dots to the eyes and jewelry make them look brighter and shinier.

34

ACCESSORIES

Like hair, facial features, and body type, accessories tell a story. The schoolgirl's book bag, plush bunny, and hair clips show her youthful innocence. Below, see how accessories add character.

Pet Lover

This young girl's collar and bell strongly identify her as an animal lover.

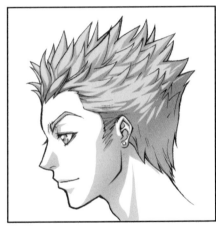

Bad Boy

Something as tiny as an earring can give this confident bad boy a bit of unconventional charm.

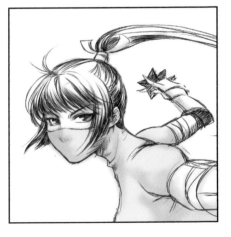

Fighter

A deadly ninja star, sleek sword, or classic pistol reflects a character's fighting style.

PRACTICE HERE

Heroine

This happy heroine is feminine and sweet. She bears a gentle and calm personality, making her a dependable friend.

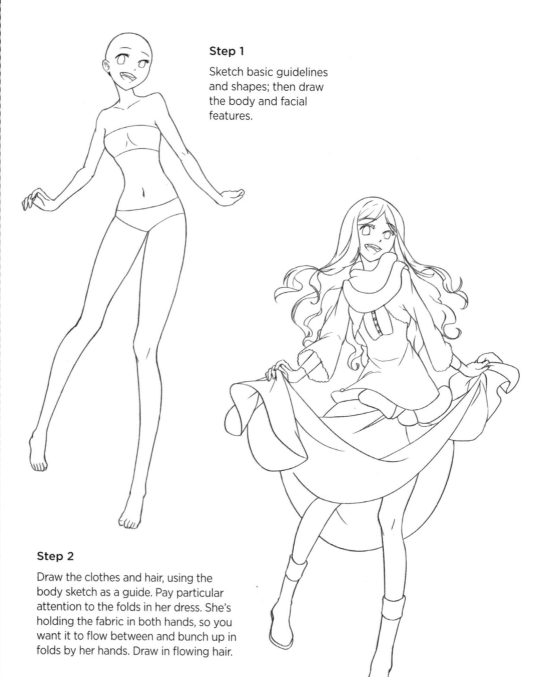

Step 1

Sketch basic guidelines and shapes; then draw the body and facial features.

Step 2

Draw the clothes and hair, using the body sketch as a guide. Pay particular attention to the folds in her dress. She's holding the fabric in both hands, so you want it to flow between and bunch up in folds by her hands. Draw in flowing hair.

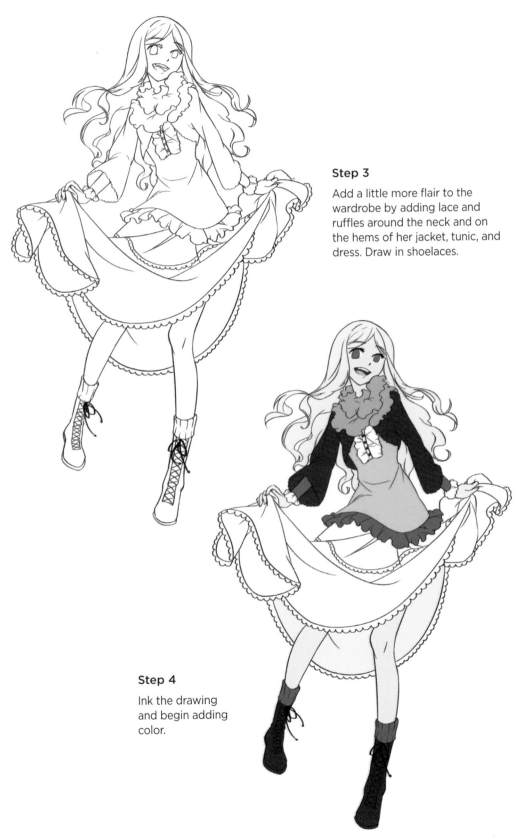

Step 3

Add a little more flair to the wardrobe by adding lace and ruffles around the neck and on the hems of her jacket, tunic, and dress. Draw in shoelaces.

Step 4

Ink the drawing and begin adding color.

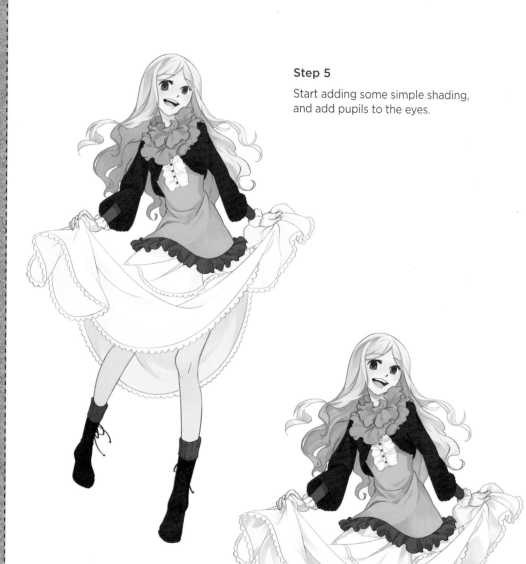

Step 5

Start adding some simple shading, and add pupils to the eyes.

Step 6

Continue building up shadows and color, such as the creases and folds around the waist, and adding more detail to her hair. Add hard and soft shadows, especially where the clothes crease.

Step 7

Select colors slightly lighter than the original colors, and brush over the areas where the light source directly hits her clothing to create highlights. Lighten the bottom of her eyes to make them shiny. To add even more dimension, slightly fade out the areas that are farthest away. Lighten the line art even more on the areas that are most exposed to the light source.

PRACTICE HERE

Ninja

Now that we've covered everyday characters, try out something more dynamic and complex. A ninja is a great character to experiment with, as ninjas are expert assassins and have extremely agile movements and action-packed lives.

Step 1

Begin with the basic shapes and lines of action. For this ninja, it may be harder to see the line of action and joints because of the extreme pose. Keep in mind that arms and legs don't shrink in length even though foreshortening makes it look like they do.

Step 2

Sketch the contours of the body, and add the facial features. Shape out the muscles, fingers, and legs. With an action pose, you want to review your sketch often to see if it looks awkward or stiff.

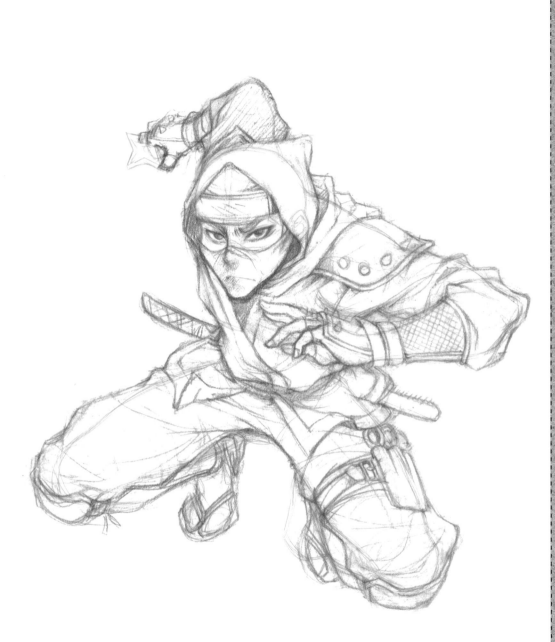

Step 3

Draw the basic clothing and accessories, including weapons, sandals, and spiked gauntlets. Carefully render the different folds and textures. Although his face will be covered, I suggest sketching the ninja's facial features to establish his personality and expression.

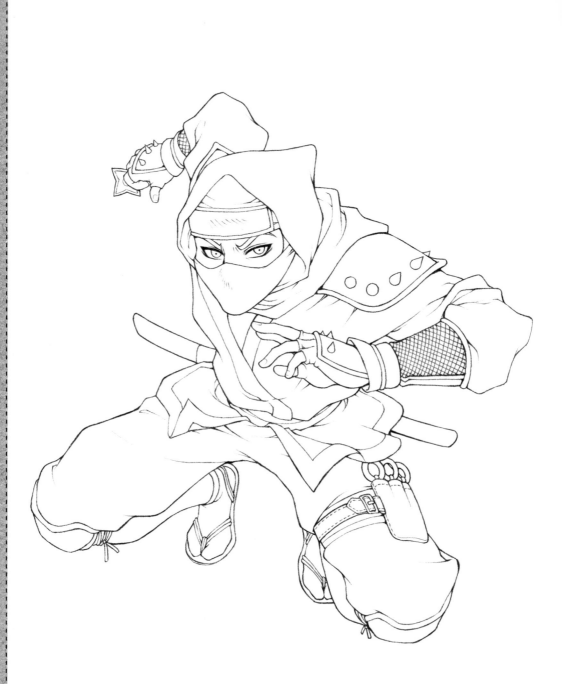

Step 4

Now ink your final drawing, sharpening up the details. As this image involves many distinct elements that are close together, be cautious about smudging. You can place a small ruler or plastic lid beneath your hand to prevent smearing your work.

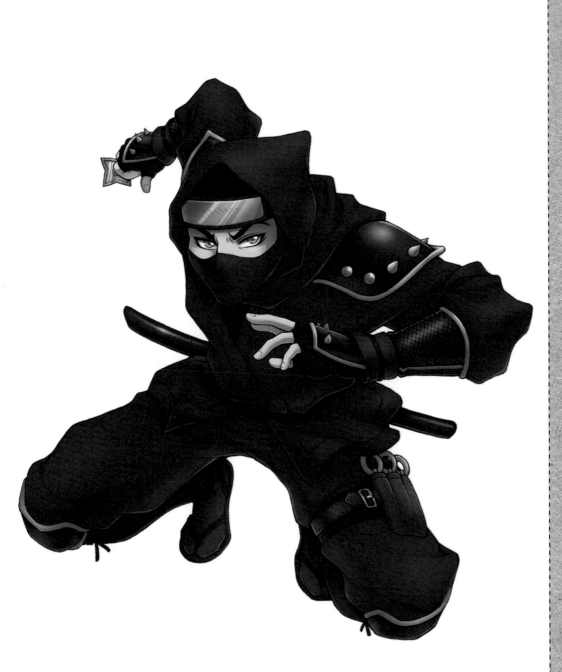

Step 5

The color palette for a ninja is basically monochromatic. His clothing, sword, eyebrows, and mask are dark gray and black. Color the band around his leg a dark brown, and let the lighter flesh tones of his fingers and area around his eyes provide a dramatic contrast to his dark apparel. Next, add silver accents to his armor, spikes, headband, and *shuriken*, or throwing star. Complete the image with piercing blue eyes, and remember to leave bright highlights in the eyes and reflective metal items.

Geek

The geek is another classic manga character that usually exists to provide comic relief. This geek character has a thick, stocky build.

Step 1

Draw guidelines and basic shapes; then work on the body contours.

Step 2

Draw in the uniform, shoes, and hair. Remember to use the body sketch as a guide as you "wrap" the clothes around him. Add thick, rectangular eyeglasses as an accessory.

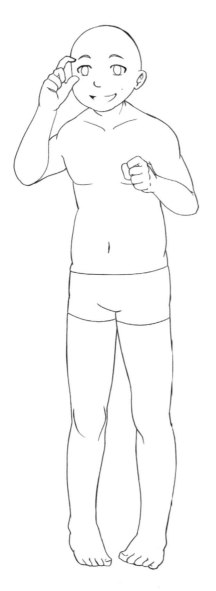

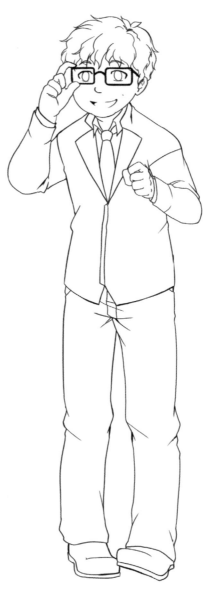

Step 3

Continue to add more detail, such as the buttons to his sleeves and tailoring lines to his coat and trousers. Add a shoulder bag to give him a studious, bookworm-type look.

Step 4

Begin laying in flat color, which comprises the most prominent color of an area. The flats should give you a general idea of what the final colored piece will look like.

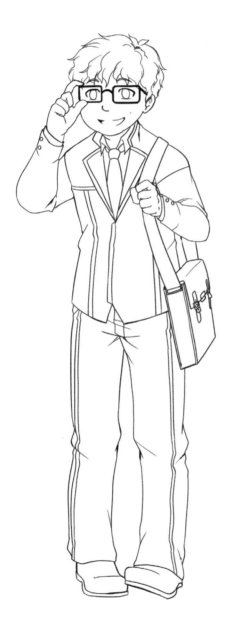

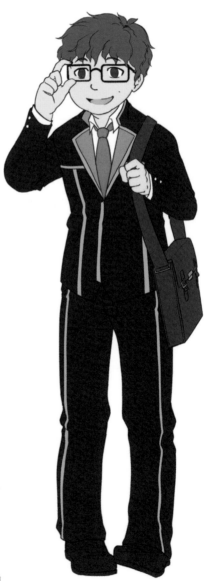

Step 5

Add some basic shading, focusing on the light source, which is from the top center. Move from section to section, selecting a basic shading color that matches each flat color.

Step 6

Select darker colors and add another layer of shading to push the shapes and add more dimension. Then select colors that are lighter than those used in step 5, adding highlights to bring in more depth and dimension.

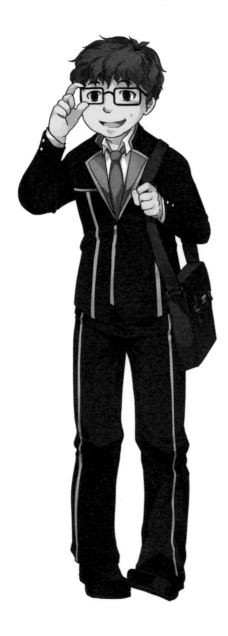

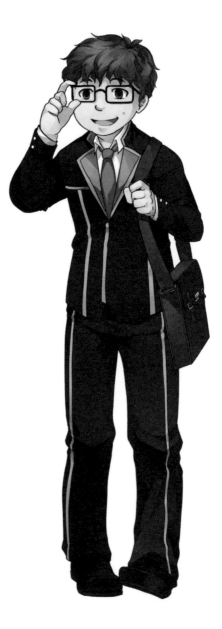

Step 7

Add some more subtle highlights, including bright white highlights to the eyeballs, followed by some dramatic glare on the eyeglasses. Then add highlights to the metal parts on the shoulder bag. Finally, add white spots to the shoes to make them shiny.

PRACTICE HERE

Villain

This villain is a big, brawny henchman. He may look dim-witted, but he just prefers brute force and breaking things rather than thinking. He has a short temper and always seems to be angry.

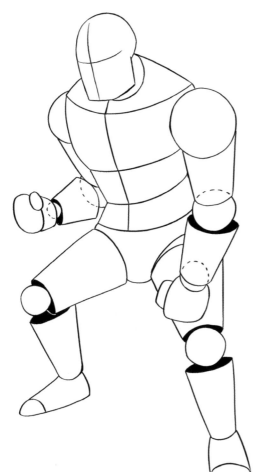

Step 1

Because this character is so bulky, basic shapes play an important role for this drawing. After drawing guidelines, use large, chunky cylindrical shapes to lay down the foundation for the bulky frame.

Step 2

Begin building the muscular form. Use reference photos of bodybuilders to help get the right look, if necessary.

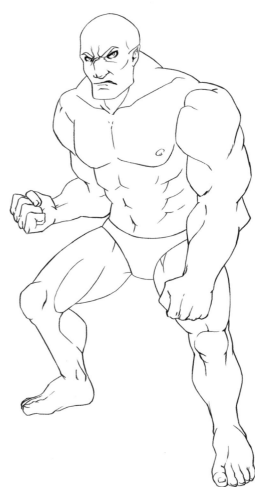

TIP

Minion or henchman characters don't always have to be weaker than the main villain. Think of ways to give supporting characters different attributes so that they balance out those with whom they interact the most.

Step 3

Now draw in the clothing and accessories.

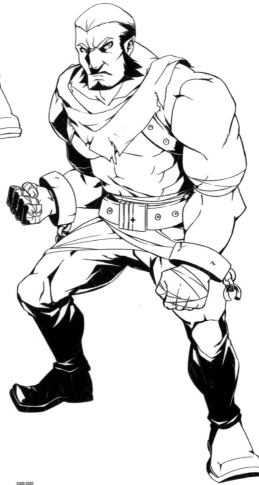

Step 4

Add some dramatic black shadows to the line art, using ink instead of color. Think about which areas would benefit the most from having these dramatic darks.

Step 5

Add flat colors to the line art. Color his clothes with black and red to add to his menacing and aggressive appearance.

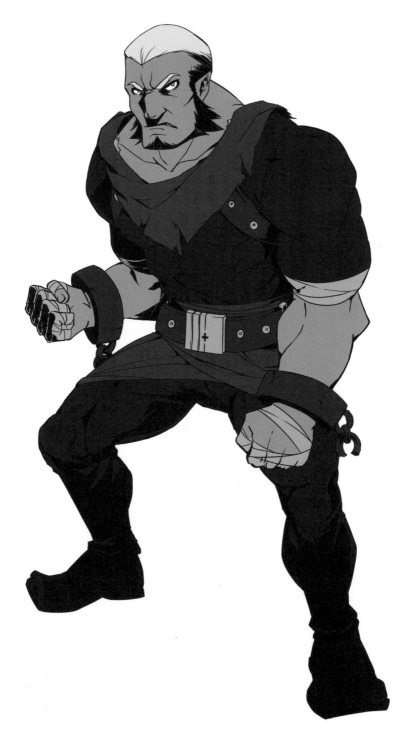

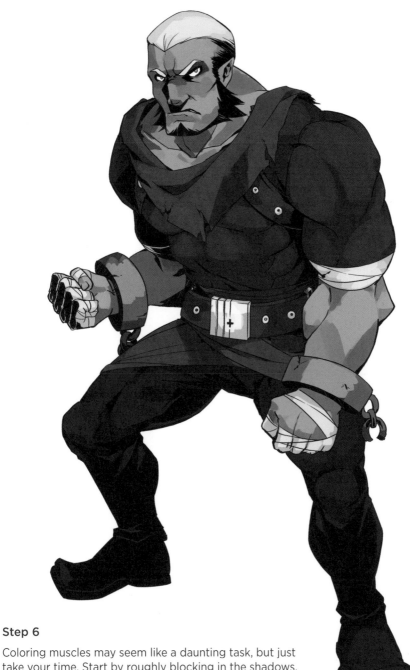

Step 6

Coloring muscles may seem like a daunting task, but just take your time. Start by roughly blocking in the shadows. Don't worry about your coloring being messy at this stage; you just want to get an idea of where the dark and light areas are.

Step 7

Blend areas with middle tones and highlights. Start tightening details like the angles in the muscles and the creases in the clothing. Add interesting angles to his face with color. Try leaving some areas with high-contrast edges between colors, while blending in others.

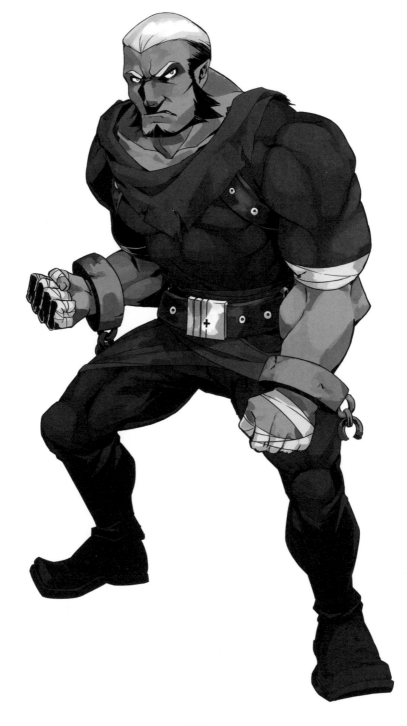

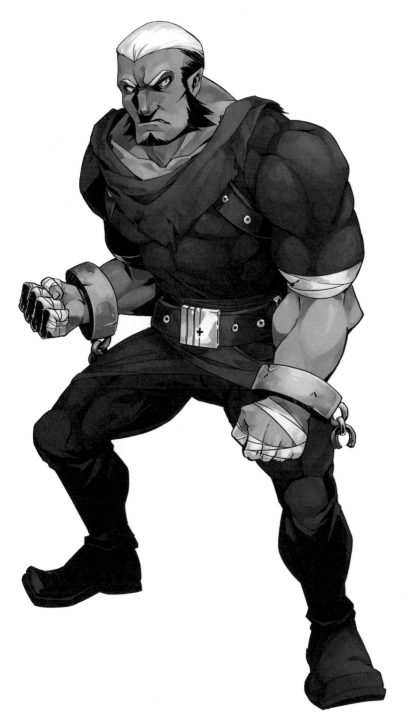

Step 8

Continue rendering and blending in some details. Use softer gradients for some areas and hard edges between colors in other areas for a more dramatic look. Then add some key highlights on the face, a few of the biggest muscles on his arms, and on his chest. Add some bright scuff marks on the giant shackles around his wrists. Consider adding reflecting light on his back arm to add more dimension to the drawing.

Basic Manga Storytelling

WRITING A PLOT

Now that you know basic manga techniques, you're ready to create your own manga chronicles! Begin by jotting down your plot ideas. Every good plot has a chapter that explains the basic premise and introduces the main character. Then a series of events builds up to a climax before the action winds down to a resolution. You could write an epic shôjo romance or shônen adventure that spans several volumes, or maybe a four-panel gag comic, or *yonkoma*, fits your style better.

SCRIPTWRITING AND THUMBNAILING

Once you have a plot, script the scenes of your manga; then create thumbnails, or miniature sketches, of pages where you plan panel layouts and character expressions. (See how the script below can be thumbnailed in the example at right.)

When laying out a scene, think of yourself as a movie director who uses different camera angles—such as the bird's eye view, close-up, or low-angle shot—to set specific moods.

PAGE 1

Panel 1: [Exterior shot of a high school]

Panel 2: [Close-up of a schoolgirl's running feet]

Sound Effect: TP TP TP TP TP TP TP TP

Panel 3: [Full front shot of schoolgirl running, looking stressed out because she is late for class]

Panel 4: [Close-up of watch on girl's right wrist]

Girl thinking: I can make it!

Panel 5: [Profile view of girl sprinting toward the school gate, with speed lines to indicate how fast she is moving. Determined expression on girl's face.]

Girl thinking: I CAN'T BE LATE!

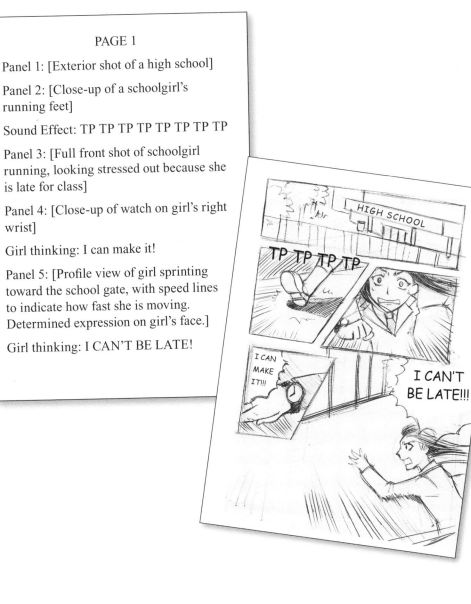

PENCILING AND INKING

With your script, thumbnails, and drawing materials on hand, you are ready to bring your manga story to life!

Step 1 Use your ruler and pencil to draw in the panel borders.

Step 2 Sketch the basic shapes and features in each panel—don't forget to include word balloons.

Step 3 Add details and finish your pencil work. Ink your drawings.

SPECIAL EFFECTS

Pump up the action with sound effects and dynamic visual cues. Write out "CRASH!!" in bold caps that illustrate the roar of an impact, or draw a burst that captures the power of an explosion. You can also draw multiple parallel lines to indicate speed. Adding special effects draws the reader deeper into your story.

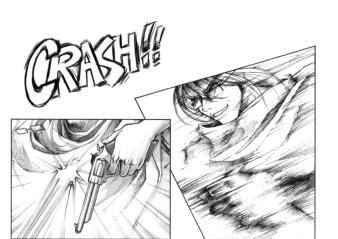

LETTERING

With a ruler and pencil, lightly draw guidelines in the speech bubble; then pencil in the dialogue. After you've worked out the letter spacing in pencil, ink over the words.

I AM A SPEECH BUBBLE.

I AM A SPEECH BUBBLE.

FINISHING UP

After inking, use an eraser to clean up visible pencil lines. Next add shading and texture with screentones. Now sit back and admire your finished manga page.

URGH-!!
THE LESSON'S OVER ALREADY?!

Introduction to Manga Chibis

The word *chibis* (pronounced "chee-bees") means "little" in Japanese. Chibis are super cute caricatures of people or animals that have been shrunken and squashed into funny, childlike creatures with big heads, stubby proportions, and silly expressions. In this section, you'll discover what gives chibis their "chibiness," including proportions, facial features, expressions, and poses. And because companion critters are a common theme in anime and manga, you'll also learn to transform common animal friends into chibis.

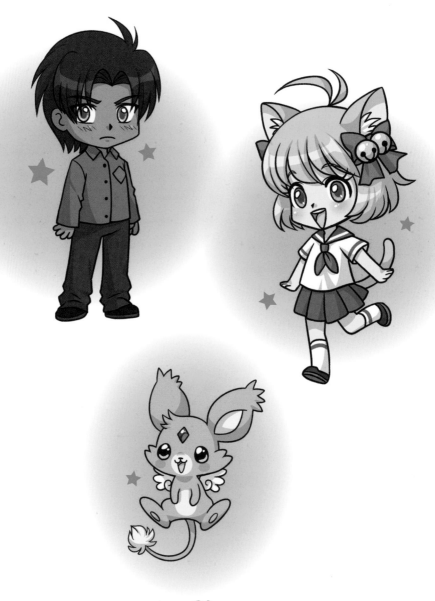

Basic Shape

The one attribute that sets chibis apart from other anime and manga characters is their proportions. They are squashed and simplified, and their features and sizes are altered to make them look as cute as possible. Common traits include an oversized head, a small body, stubby limbs, and big eyes.

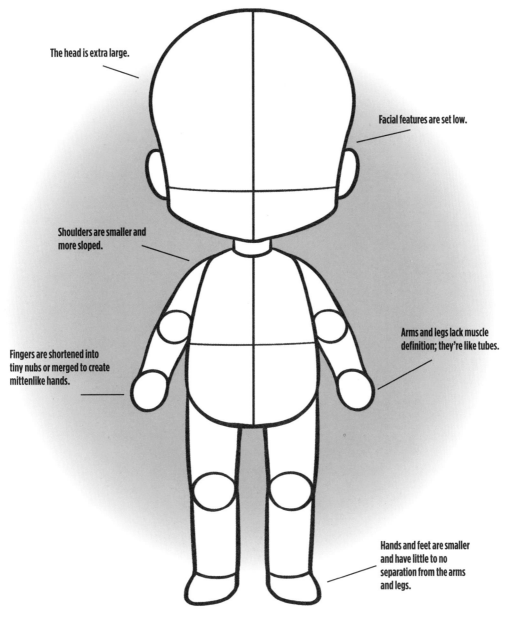

The head is extra large.

Facial features are set low.

Shoulders are smaller and more sloped.

Arms and legs lack muscle definition; they're like tubes.

Fingers are shortened into tiny nubs or merged to create mittenlike hands.

Hands and feet are smaller and have little to no separation from the arms and legs.

The body is shortened.

Basic Face

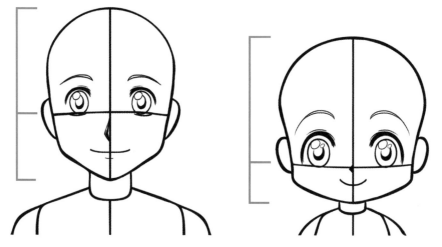

Front View
Compared to a normal face, chibi facial features are larger and sit toward the bottom half of the face. The forehead is large, and the eyes are wider and set below the center of the face. Chibi eyebrows arch more dramatically, resulting in a wide-eyed, childlike expression. The chibi nose is a tiny triangle, and the mouth is shorter. Also note the rounder, wider head; flattened chin; and short, thin neck. Use the blue guidelines to measure the differences in proportion and placement between the upper and lower halves of each face.

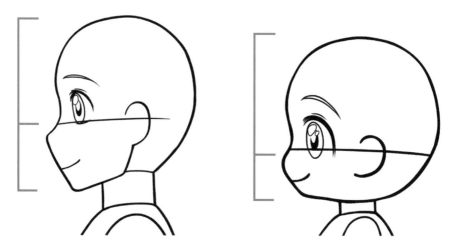

Side View
In the side view, the facial features are still compact and placed lower on the face, resulting in a larger, broader forehead. The jawline and chin are smoothed out and simplified, which makes the chibi character appear shorter and pudgier. The head is more circular, whereas the eye and eyebrow are larger and more pronounced. A small protruding bump indicates the nose, and the mouth and neck are both shorter. You'll also notice the ear doesn't connect to the edge of the jawline.

Basic Body

Chibis come in all shapes, sizes, and proportions, but the most common body shape is shown at right. In this example, the body and legs are approximately the same height, and the head is larger than both.

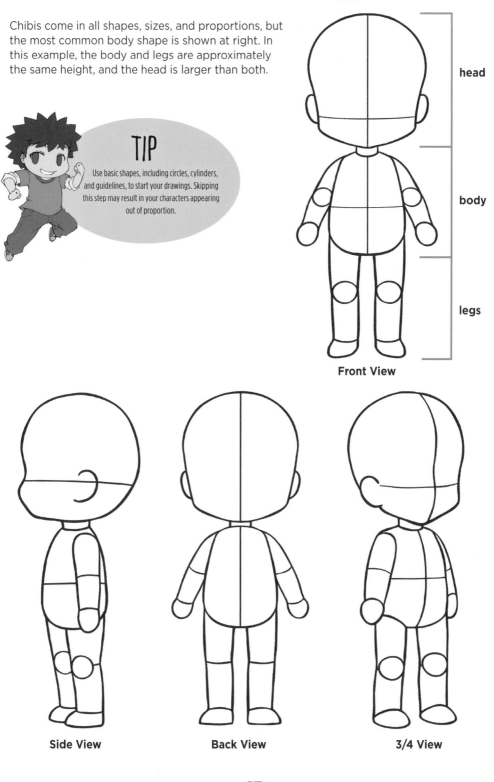

TIP

Use basic shapes, including circles, cylinders, and guidelines, to start your drawings. Skipping this step may result in your characters appearing out of proportion.

head

body

legs

Front View

Side View

Back View

3/4 View

Hands

The average chibi hand is a short, chubby version of a normal hand. Some styles, such as the mitten-like hand, don't have fingers; others have fingers that are little nubs.

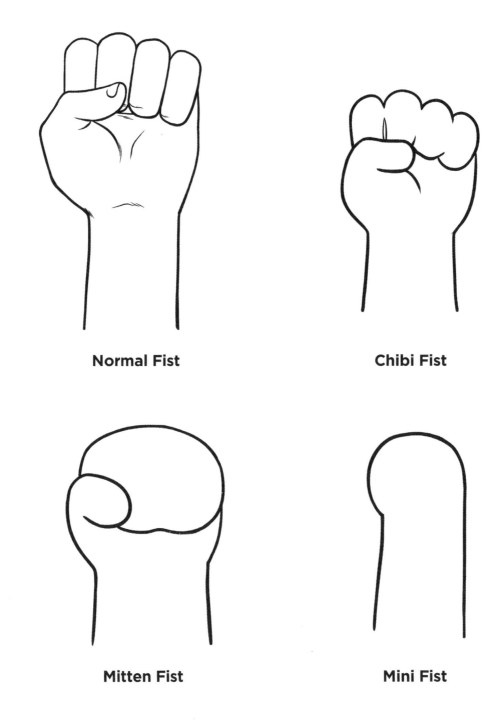

Normal Fist

Chibi Fist

Mitten Fist

Mini Fist

Normal Hand

Chibi Hand

Mitten Hand

Mini Hand

Feet

Chibi feet begin as simplified versions of normal feet. The foot shortens, toes shrink and get stubbier, and joints disappear.

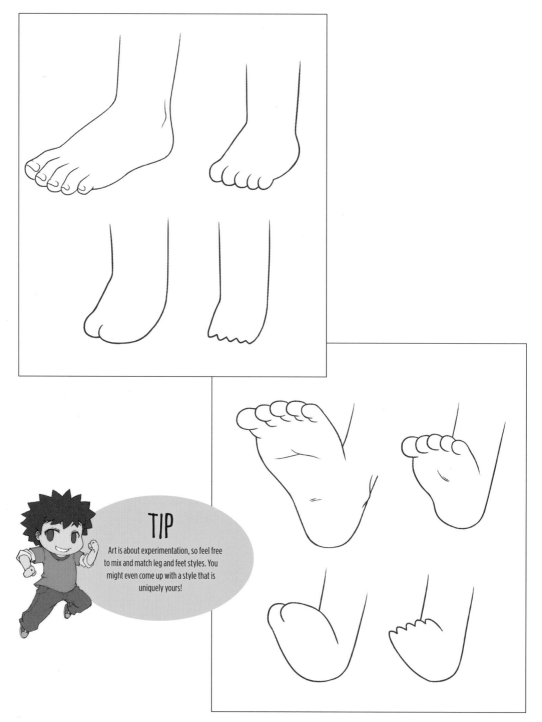

TIP

Art is about experimentation, so feel free to mix and match leg and feet styles. You might even come up with a style that is uniquely yours!

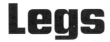

Chibi Legs

Average chibi feet have standard legs: short and thick with little to no definition. Indents at the top of the foot and a slight curve outward at the heel help distinguish the feet from the legs.

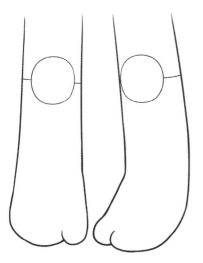

Mitten Legs

With mitten-style feet, legs are usually wider at the ankle and become gradually narrower moving up the thighs. Ankles are barely indicated with a slight bend at the top of the foot.

Mini Legs

Mini legs have no definition. The width is consistent the entire length of the leg, which is straight and cylinderlike. Knees aren't rendered at all; however, keep in mind where they are if you need to bend the legs.

Eyes

Eyes define a chibi's personality as much as style and pose do. And they're particularly important where chibis are concerned because they're often extremely large in proportion to the face. Review the eyes below; what might you be able to tell about a chibi's mood?

Traditional
- Lids and eyebrows arch upward.
- Eyeballs are oval-shaped and clear with a pupil and highlights.
- For boy chibis, remove the long lashes.

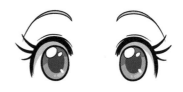

Almond-Shaped
- Eyelids have narrow outer edges for a focused look.
- Add eyelashes or makeup for a girl chibi.

Doe
- Long eyelashes, white highlights, and a furrowed brow communicate innocence.
- Girl chibis that are soft-spoken and kind often have doe eyes.
- Remove the eyelashes for shy guys.

Sly
- Narrow eyes suggest complex feelings.
- Eyelids are slimmer; eyeballs are smaller.
- Villains are good candidates for this eye style.
- For a demonic look, add catlike pupils and red eyeliner.

Girlie
- Many shoujo and anime feature girlie eyes to make characters seem ultra-feminine.
- They usually sport makeup, a star-shaped highlight, and lush eyelashes.

Concave
- Eyeballs are squarer; the eyelids slope down and outward.
- These eyes work for male and female chibis.
- A character with concave eyes is probably a solemn, deep thinker.

Happy
- Eyes close and form curved arcs.
- Characters with these eyes are overjoyed and cheerful.

Winking
- A popular expression for happy-go-lucky characters with go-getter attitudes.

Irritated
- Eyelids are horizontal; eyeballs look to one side.
- To enhance this annoyed look, the eyebrows should gather in the center and angle downward.

Closed/Sleeping
- Eyelashes and the arcs of the eyelids point downward.
- Characters with closed eyes are often wishing or sleeping.

Sad
- Large and droopy, with eyelids that are open but angled down toward the corners.
- For a "welling up" appearance, add white spots to the insides of the eye.
- Eyebrows angle upward where they meet; then gradually angle downward, following the arc of the eye.

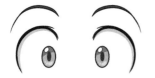

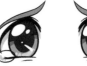

Surprised/Shocked
- Eyelids are large and extend outward in wide circular shapes. Irises are small with a lot of white space around them.
- Arching the eyebrows higher and wider above the arc intensifies this expression.

PRACTICE HERE

Expressions

Facial expressions convey a character's emotions and mood. Chibi expressions tend to be highly exaggerated, often for comedic effect. The illustrations below demonstrate how various expressions translate between forms.

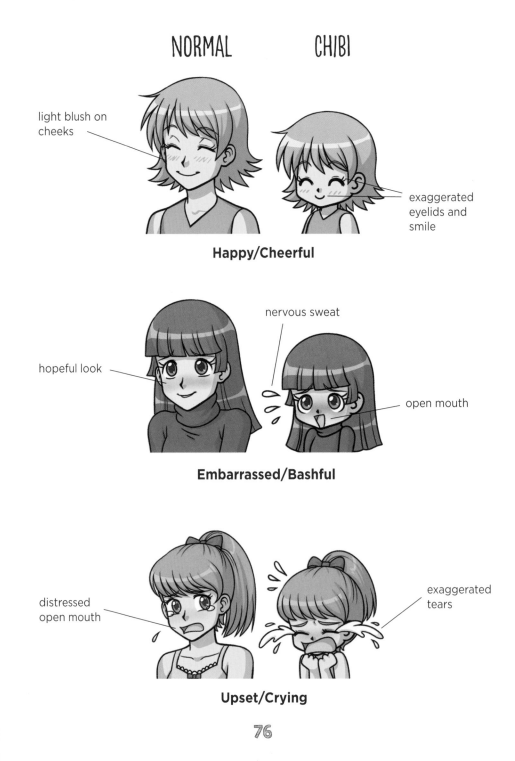

NORMAL CHIBI

light blush on cheeks

exaggerated eyelids and smile

Happy/Cheerful

hopeful look

nervous sweat

open mouth

Embarrassed/Bashful

distressed open mouth

exaggerated tears

Upset/Crying

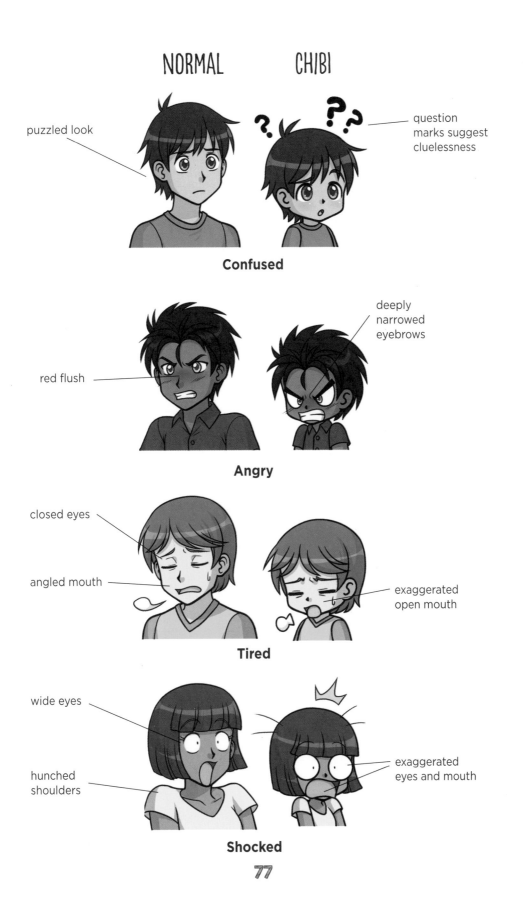

NORMAL CHIBI

puzzled look

question marks suggest cluelessness

Confused

deeply narrowed eyebrows

red flush

Angry

closed eyes

angled mouth

exaggerated open mouth

Tired

wide eyes

hunched shoulders

exaggerated eyes and mouth

Shocked

Hairstyles

A hairstyle is important when developing a chibi character because a chibi's shape lacks detail. Some chibi styles are so simplified that the only distinguishing feature between characters is the hair and clothes. Drawing the right hairstyle can enhance a character's look and personality, and there are virtually no limits. Hair can be any length, style, color, or shape.

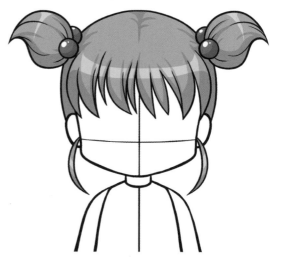

Long, Straight Traditional style with blunt edges and straight bangs.

Pigtails Short pigtails are gathered high on the head. The bangs fall on the forehead and clump together to form points at the tips.

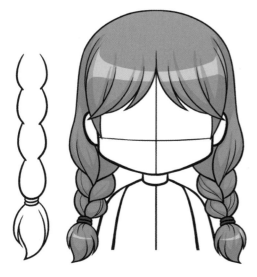

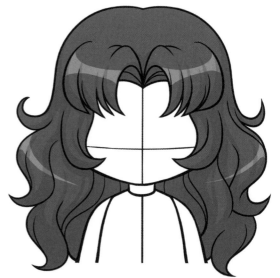

Braids This character has symmetrical braids. Her bangs divide down the middle and are tucked behind her ears. To draw less complex braids, simply sketch them as outlines.

Long, Wavy Falls in random waves around the face and shoulders. The bangs are poufy, and tufts of hair flank the cheeks and cover the ears, adding volume and body.

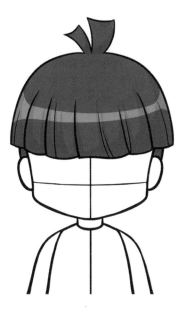

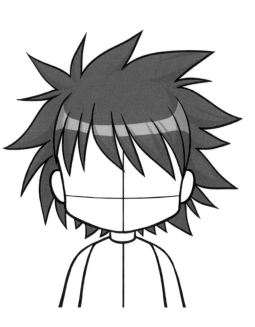

Bowl Cut The bowl cut features bangs cut straight across the forehead and a cowlick.

Spiky Hair juts out in every direction in uneven and random chunks. Uneven bangs fall against the forehead.

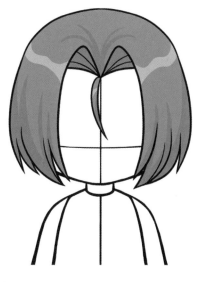

Short Cut Trimmed all the way around the head, with the longest pieces on top forming short, spiky waves.

Widow's Peak with Long Bangs A widow's peak is hair that grows toward the center of the forehead and forms a V. This short style sports extra-long bangs that partially cover the eyes.

Clothes

Below is only a small sampling of what you have to choose from, so feel free to create your own chibi clothes!

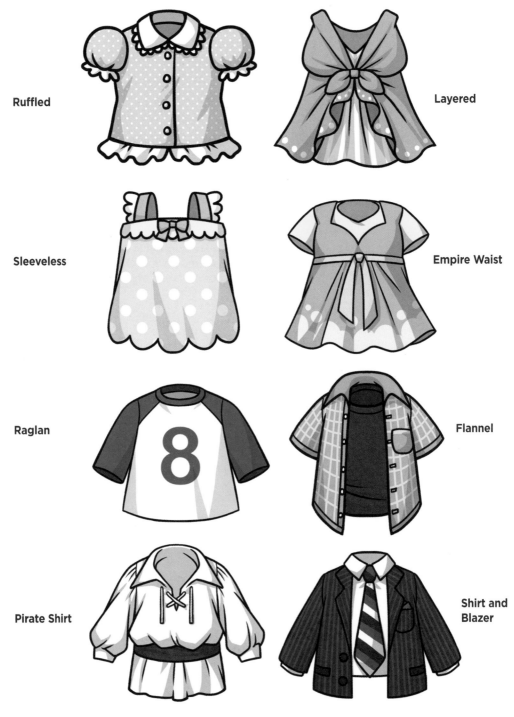

Ruffled

Layered

Sleeveless

Empire Waist

Raglan

Flannel

Pirate Shirt

Shirt and Blazer

Pleated Skirt

 Short Shorts

Skirt and Sarong

 Capri Pants

Sweatpants

 Jeans

Cargo Pants

 "Camo" Shorts

Chibi Girl

The preliminary steps for drawing all chibi faces are essentially the same.

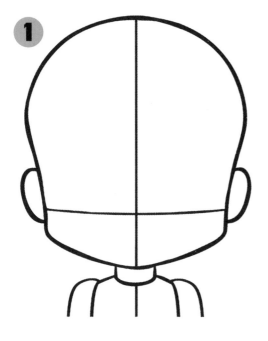

Sketch the basic head shape and guidelines. Draw the ears even though the hair covers them. It's always good to draw the shapes for all of the features, even if they aren't visible in later steps.

Draw in the features. Pay attention to how the guidelines help establish where the features sit.

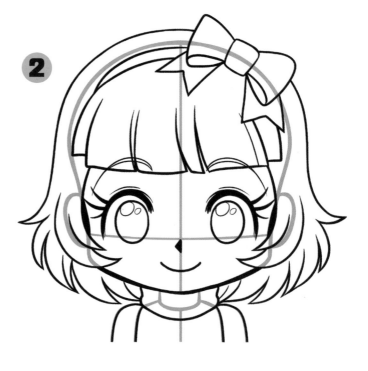

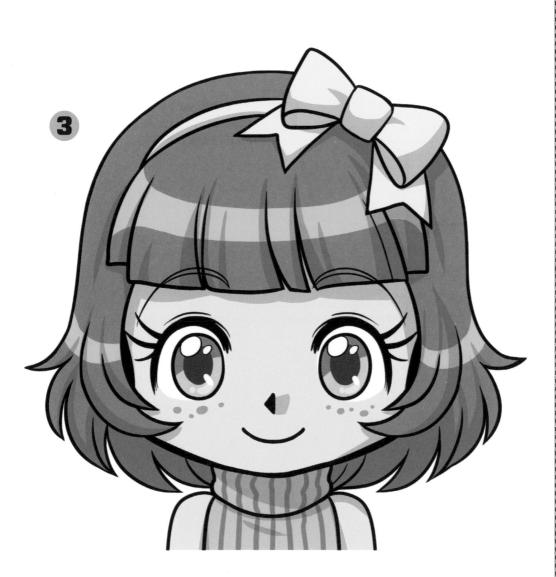

Erase unnecessary sketch lines and add your base colors, followed by shading and highlights. Add dark blue pupils to the center of the eyes along with highlights. For added flavor, give your chibi girl a few freckles.

Chibi Boy

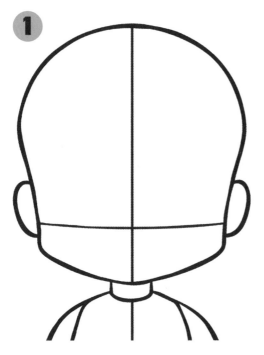

1

Sketch the basic head shape and guidelines. This boy's shoulders are broader than the girl's.

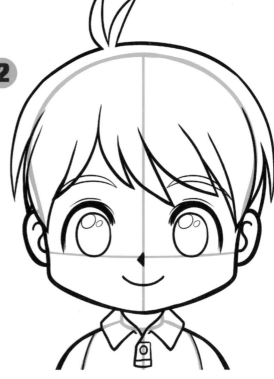

2

Add the eyes, noticing how the boy's eyes rest directly on the centerline, whereas the girl's eyes are set slightly lower. This boy also has thicker eyebrows. Next add the nose and mouth.

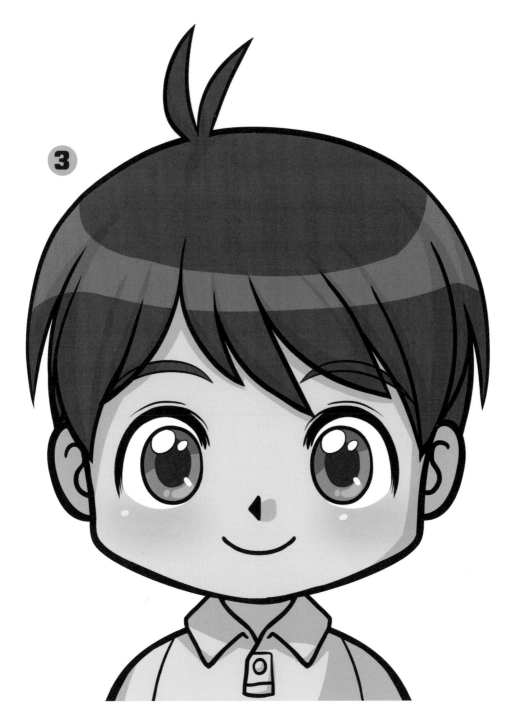

Erase unnecessary guidelines. Then add your colors and highlights. You can give the boy brown hair and green eyes, or any colors you like. Add highlights to his hair to make it appear shiny and round. Add a pink flush to his cheeks so he appears as if he's been playing outside.

Chibi Girl

To draw a more lively front view than a standing chibi offers, try moving body parts or changing stances. Raise the character's arms, bend its legs, or give it a quirky expression. There are many ways to add feeling to a seemingly straightforward pose. In this example, our chibi girl has been caught by surprise!

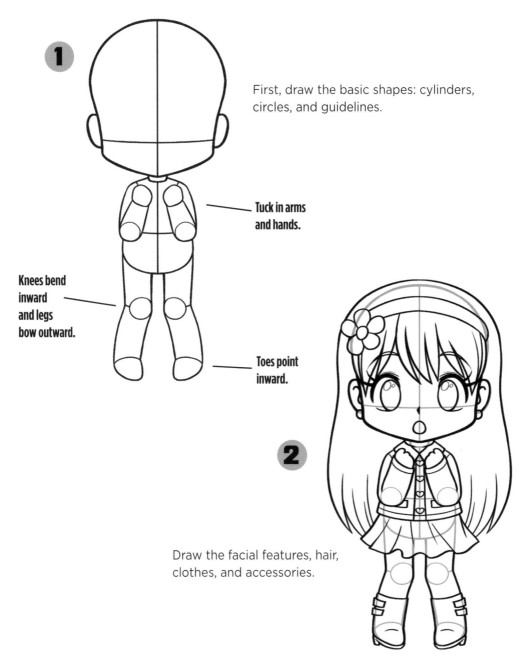

1

First, draw the basic shapes: cylinders, circles, and guidelines.

Tuck in arms and hands.

Knees bend inward and legs bow outward.

Toes point inward.

2

Draw the facial features, hair, clothes, and accessories.

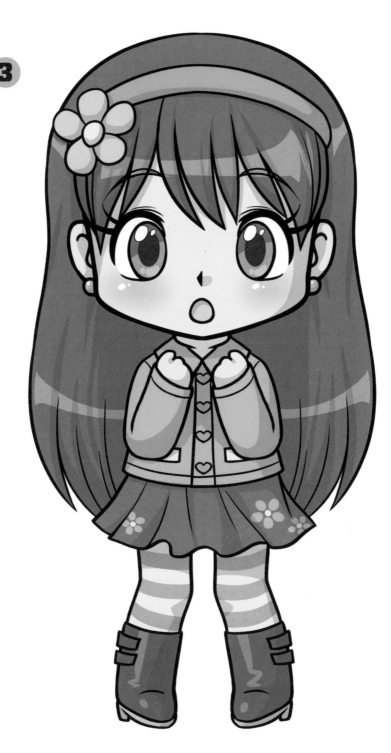

Add solid colors before shading or highlighting. Color in the pupils and add high-lights to give the eyes depth. Add a blush to her cheeks.

Chibi Boy

Use guidelines to keep the side-view chibi from appearing flat. Use a few tricks to add dimension. For example, draw the arm and leg on the opposite side so they are visible. Always think three-dimensionally!

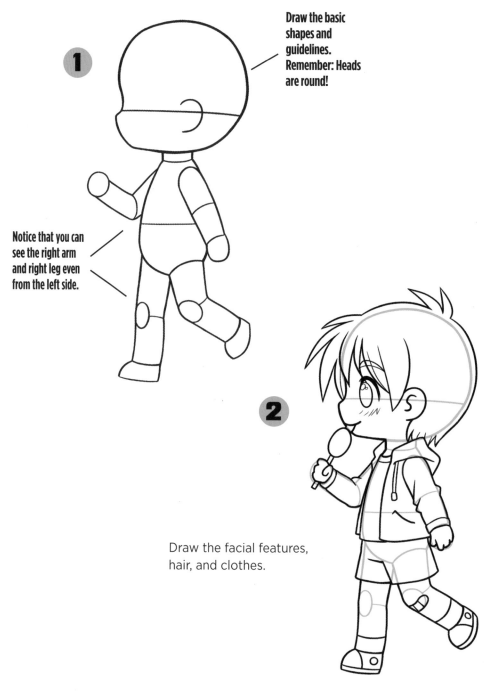

1

Draw the basic shapes and guidelines. Remember: Heads are round!

Notice that you can see the right arm and right leg even from the left side.

2

Draw the facial features, hair, and clothes.

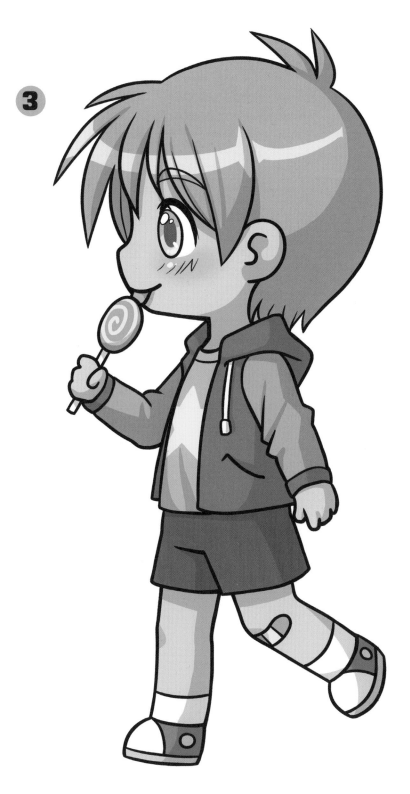

3

Add color, shading, and highlights.

Chibis in Action

Study the red line of action in these poses. The line of action is an imaginary line extending from the head to the spine (or the feet) that shows the direction and flow of a character's pose. Drawing the line of action first is a handy way to figure out how and where to place the arms and legs.

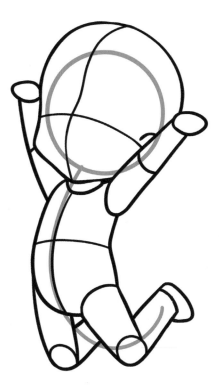

Jumping

Pay attention to the way the legs, arms, and head line up with the shape of the torso to create one fluid movement throughout the body. The back is arched so the belly sticks out and the hips jut slightly forward. The head tilts up and slightly back. Both arms are straight and raised. Each leg bends at the knees so this character appears to be jumping off the ground.

Running

In this pose, the upper body angles slightly forward in the same direction the character moves, while the head tilts upward. Mimicking real-life running, the arms are in opposite positions to maintain balance. The hands are balled into fists. The left leg extends forward, with the foot nearly striking the ground. The right leg is lifted high behind the character's body.

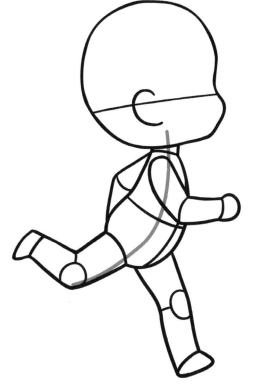

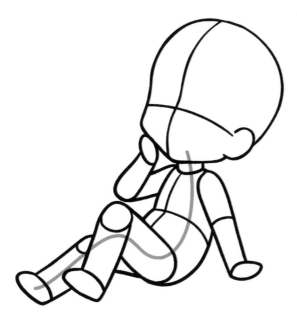

Giggling

Characters in this pose can be drawn sitting on a flat surface or floating. The torso is bent at the waist. One arm is straight and extends downward. The other arm bends, with a hand touching the mouth, as though concealing a smile. One leg bends with the knee raised higher than the other leg to create contrast and make the image more dynamic.

Superhero

This strong line of action extends all the way from the fist in the raised arm to the toes of the extended leg. All the body parts support the action pose by lining up with each other. The left arm bends and thrusts backward, with the hand in a fist to demonstrate strength. The right arm extends straight above the character's head. The left leg is straight, and the right leg bends at the knee.

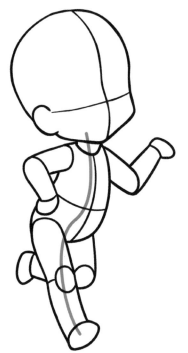

Food Server

The top of the torso bends forward a bit. The hips jut back at a slight angle, and the head cocks to the right to give this character attitude. The right arm is bent, with the hand propped on the hip. The left arm extends slightly, as if this character is carrying a tray.

Cheerleader

Body and head are straight and aligned with each other. Both arms extend straight outward in a "Y" shape from the torso. The hands bend at the wrists; the palms are open and face upward. Both legs extend outward—the arms and legs together should make an "X" shape, and the knees bend slightly for a more natural look.

Flying

The body parts are aligned in a straight line of action. The upper torso angles upward, following the line of the head. The fully extended right leg continues the line of action, making the body appear long and streamlined. The left leg bends at the knee and tucks into the stomach and chest to suggest speed.

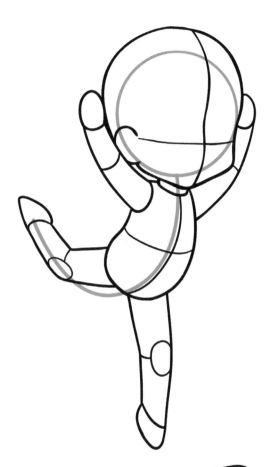

Dancing

The line of action indicates the flow of the body. The torso is straight and aligned with the head. The hips tilt toward the rear to support the legs. Both arms curve slightly as they lift upward. The hands are open and extended. The left leg extends straight through the toe, which is pointed at the tip. The right leg bends at the knee and raises high behind the character.

Tumbling

The torso aligns with the head, but at an extreme angle to depict falling. The arms extend behind the character, as both legs have lost their footing. Positioning one leg closer to the body than the other makes the pose more dynamic.

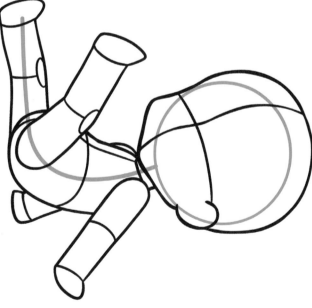

Jumping Chibi Girl

1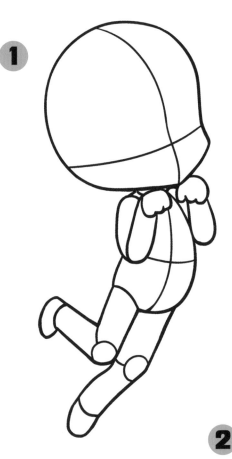

Begin with the basic shapes and guidelines. Start with a line of action as previously shown. To achieve the cat girl pose, tuck both hands under her chin and curl her hands inward so they resemble paws. Make sure her feet are off the ground so she appears to be mid jump. Raise one leg high behind her for added charm.

2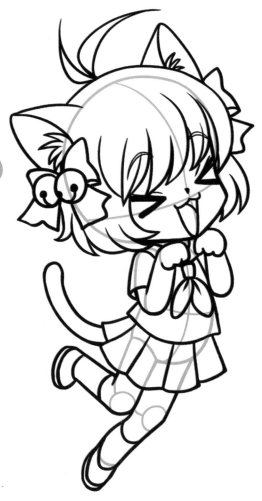

Draw the hair, facial features, clothes, and shoes.

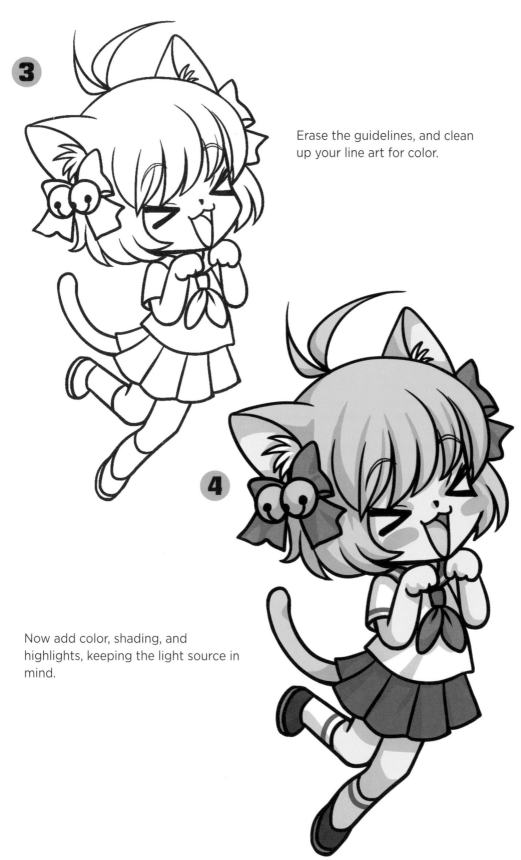

3

Erase the guidelines, and clean up your line art for color.

4

Now add color, shading, and highlights, keeping the light source in mind.

Running Chibi Boy

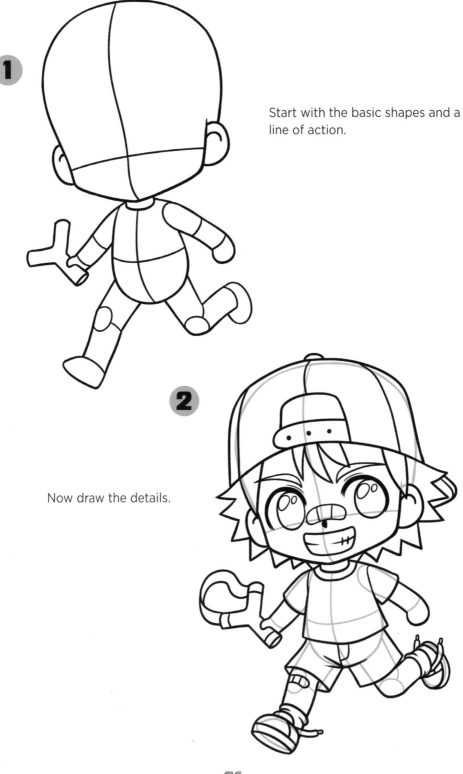

1

Start with the basic shapes and a line of action.

2

Now draw the details.

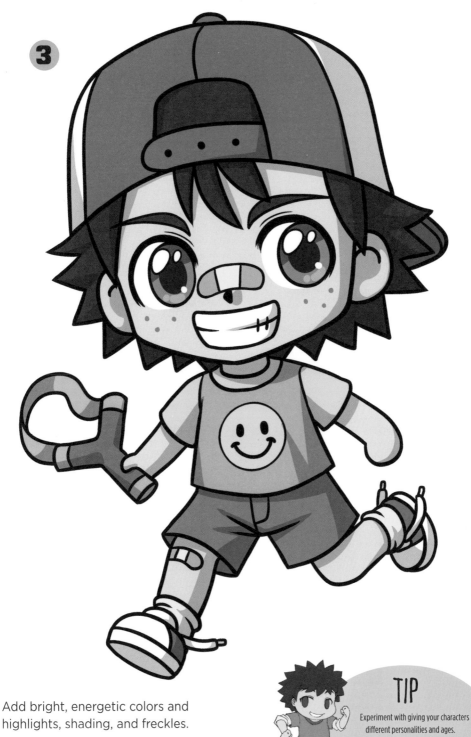

3

Add bright, energetic colors and highlights, shading, and freckles.

TIP

Experiment with giving your characters different personalities and ages. How about a baby ninja or a superhero grandpa?

Baby Chibi

Chibis come in all shapes, sizes, and ages, including babies, seniors, and everything in between. Remember the chibi fundamentals, and then pinpoint features that identify age, such as wrinkles, baby fat, and so on.

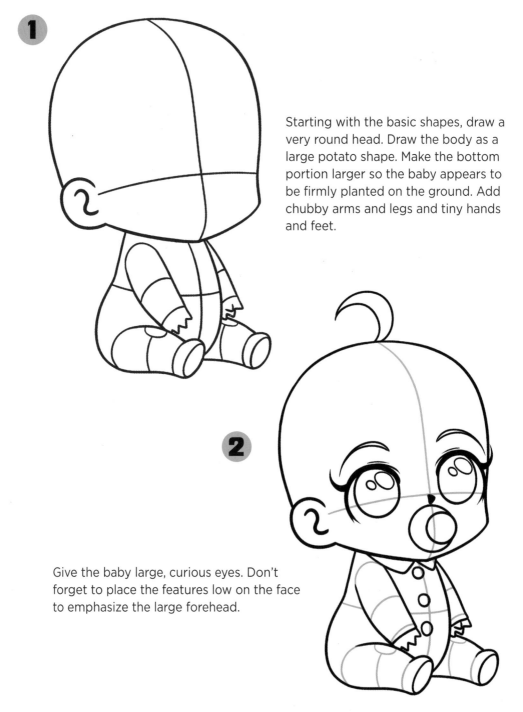

Starting with the basic shapes, draw a very round head. Draw the body as a large potato shape. Make the bottom portion larger so the baby appears to be firmly planted on the ground. Add chubby arms and legs and tiny hands and feet.

Give the baby large, curious eyes. Don't forget to place the features low on the face to emphasize the large forehead.

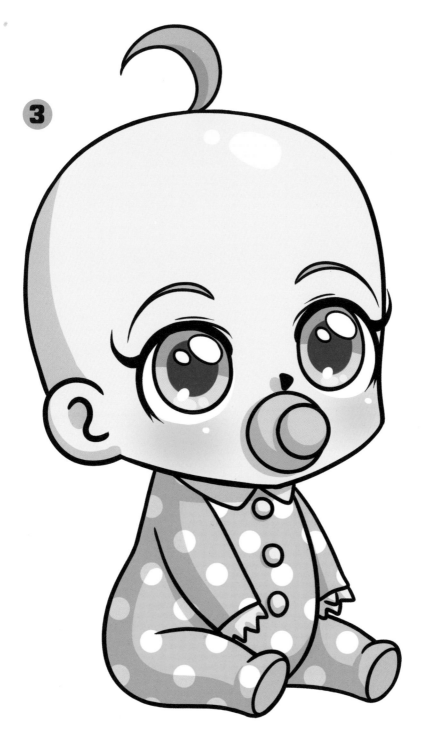

3

This baby has light blue eyes and wears a pink and yellow onesie. Add shading to the back of the head, body, and arms to identify the light source as coming from the front-right side. Add dark blue pupils and a light blush for rosy cheeks. A small highlight on the baby's forehead makes the skin look smooth and clean.

Elderly Chibi

Senior citizens often have wrinkled skin, stooped posture, and gray hair. Consider these details when drawing elderly chibi characters.

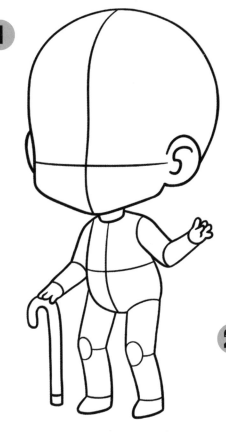

1

Start with the basic shapes. Pay attention to how her body hunches over slightly, a telltale sign of her age. Add slight bends in the knees to give the sense that she walks at a slow pace.

2

Now add the details. Granny's eyes squint slightly, and there are wrinkles below her eyes and next to her mouth. Keep her clothing simple and comfortable.

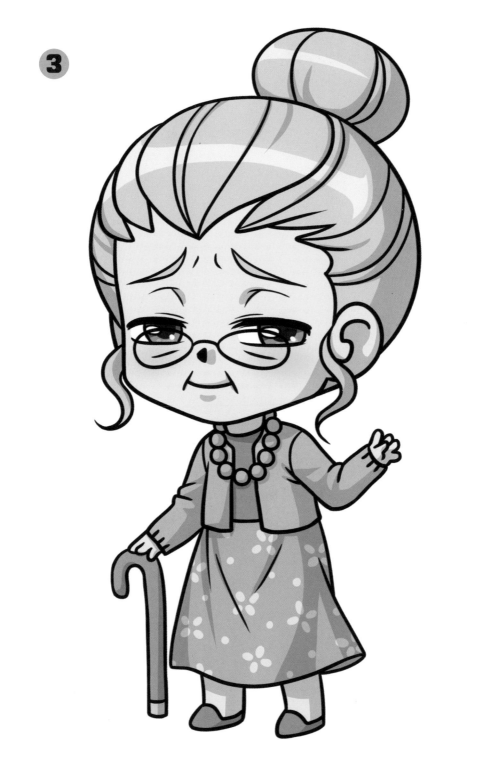

3

Add subtle colors for this character. Darken the pupils and add highlights to give her gaze more vitality.

Chibi Critters

Take a look at the diagrams of a normal dog and a chibified dog. Notice that the chibi critter's head is much larger than its body, and many of the contour lines are simple. Additionally, the legs are shorter and stouter, and the paws are noticeably smaller—and very cute!

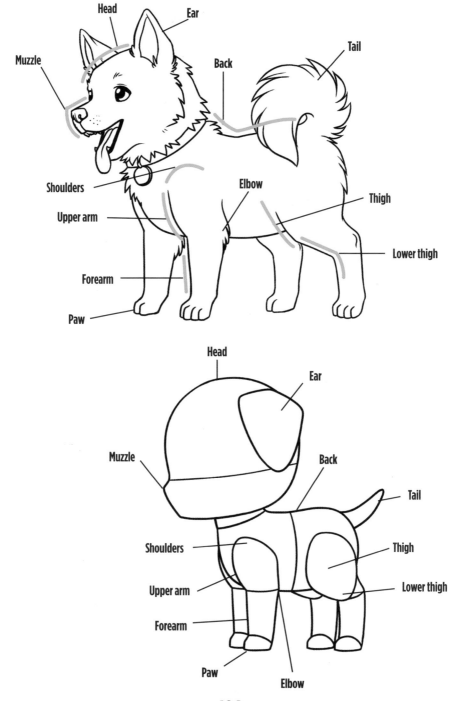

You can draw four-legged chibi critters in a variety of poses. Notice again how the shapes of the face change with each angle and that even when the angles change, the character still appears to be the same shape, height, and size from all views.

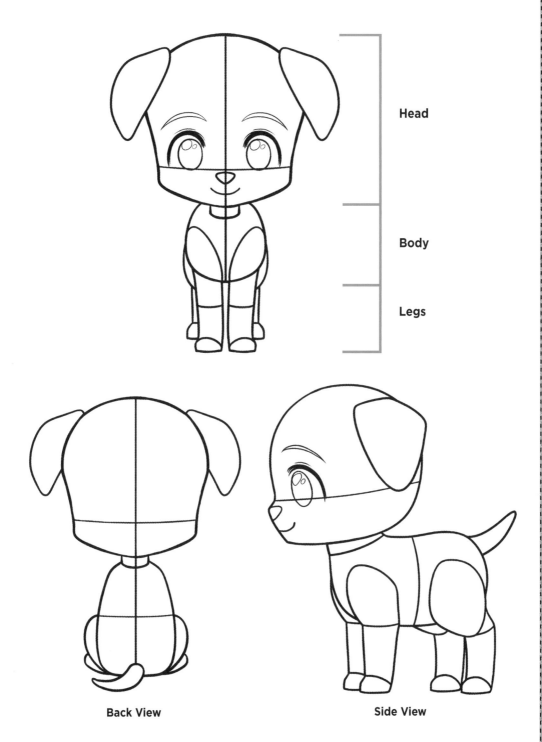

Head

Body

Legs

Back View

Side View

Critter Arms & Legs

Below are examples of human chibi limbs and animal chibi limbs.

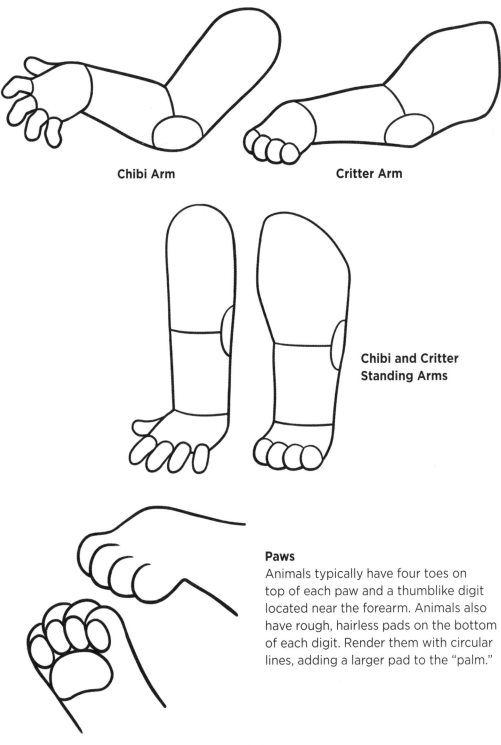

Chibi Arm

Critter Arm

Chibi and Critter Standing Arms

Paws
Animals typically have four toes on top of each paw and a thumblike digit located near the forearm. Animals also have rough, hairless pads on the bottom of each digit. Render them with circular lines, adding a larger pad to the "palm."

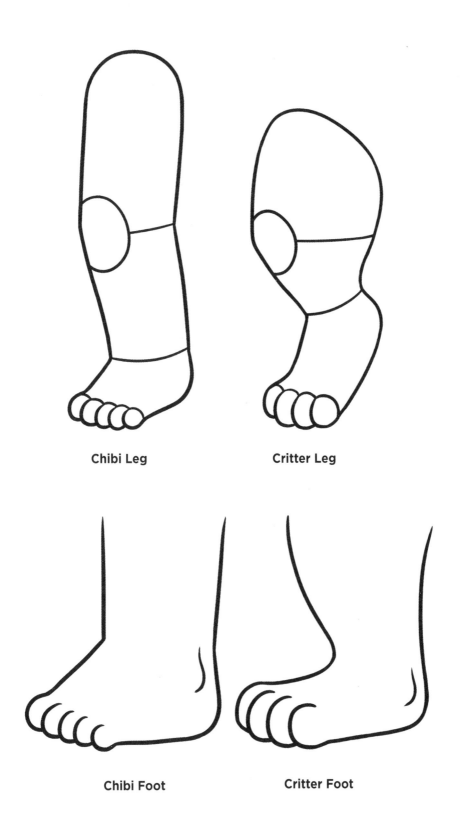

Chibi Leg

Critter Leg

Chibi Foot

Critter Foot

Critter Poses

Animals have a wide array of expressive poses, some of which are unique to specific critters. Below are a few familiar poses for dogs and cats.

DOG POSES

Lying Down

The body is flat on the ground, with both front paws resting under the chin. The back legs fold under the thighs, and the hind foot is flat.

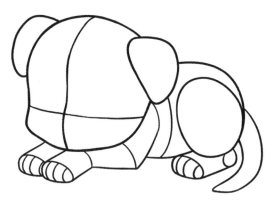

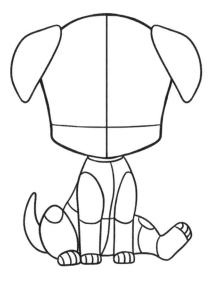

Sitting

Dogs sit on their rears, with their legs curled under them or with one leg extended to the side. Both front limbs are straight and in front of the body to support the dog's weight. When drawing this pose, the head may tilt slightly to add personality.

Begging

Draw the torso at a forward-facing angle. The head should tilt upward, with the muzzle pointing toward whatever the dog is looking at. Raise the front paws and bend the elbows and wrists. Draw the feet flat on the ground. The tail appears to be in mid wag.

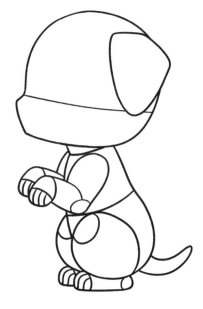

CAT POSES

Grooming

Draw the body in a seated position. The back legs fold under the thighs, and the back paws peek out. Draw one front arm so it extends straight under the body, and draw the other arm toward the mouth for cleaning. Tilt the head forward slightly. Draw the tail so it seems to swish back and forth.

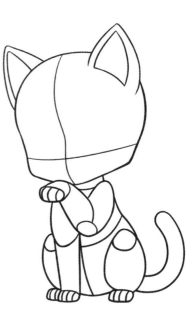

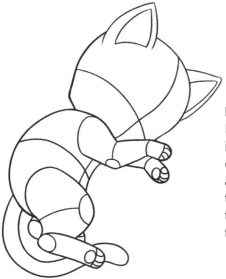

Resting

In this pose, the head and torso curl slightly inward. Draw the front legs loosely stretched out in front, with the elbow and wrist joints at a relaxed angle. For the hind legs, either tuck one under the other or draw them both tucked in. The tail can rest under or around the cat's body, or in a loose curl.

Stretching

Draw the head angled slightly upward. The cat crouches low to the ground, so the torso should be angled, with the tail sticking up. Draw the front limbs stretched straight in front, with the paws extending outward. The hind legs should appear fully extended so the cat stands on his paws. Lastly, draw the tail curling forward, and angle the ears back.

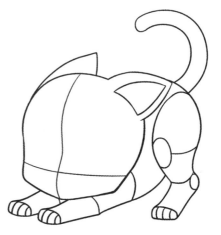

Critters in Action

Critter action poses vary depending on the animal and the environment. For instance, critters that walk on two legs often have different poses than four-legged critters. Large, heavy critters may have different actions than critters with slim, agile bodies.

Running

Most critters run on four legs. The size of the head is exaggerated and the legs narrow to tiny paws. Note how the ears appear to fly behind the head.

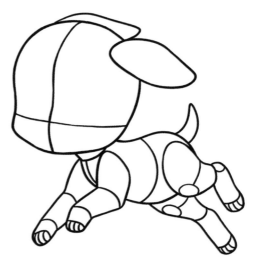

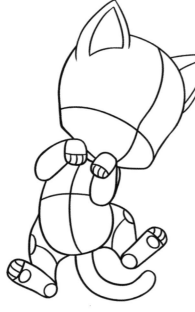

Rolling

Begin by drawing this chibi kitty's head, ears, body, paws, and tail. Pay attention to the curved line of action. The head faces one direction and the body curves into a C shape. Tuck both front paws under the chin and stretch the hind legs toward the sides.

Hopping

This chibi rabbit has a large head, simplified ears, a small body, and an exaggerated tail. The two front legs taper toward the paws, and the larger hind legs have long simplified feet. The ears bend backward as if she's running against the wind.

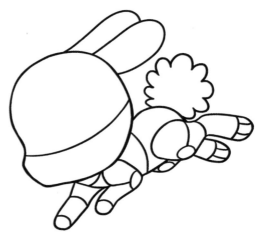

Frightened

Animals have specific reactions that demonstrate fear. Even without a facial expression, the characteristics of this pose work together to convey that this is a scaredy-cat.

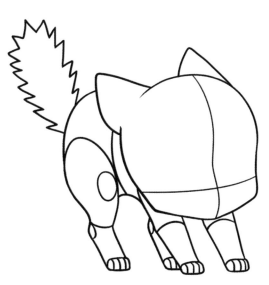

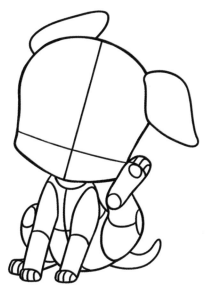

Scratching

This sitting chibi dog leans slightly to his left, with his head angled. The ears should appear floppy to add movement. Plant his two front paws firmly in front of his body for support. Draw the left hind leg and foot mid scratch for a convincing pose.

Dashing

Dashing is a faster, more urgent form of running. When rabbits dash, they use their front legs and appear to run on all four limbs. The front legs tuck close to the body, paws facing down and backward. The thighs also tuck into the body and the back feet are parallel to the body. These elements work together to heighten the intensity of the movement.

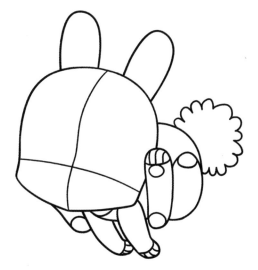

Chibi Dog

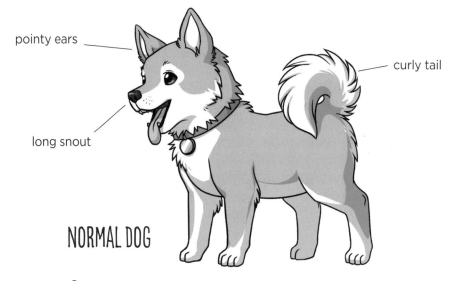

pointy ears

curly tail

long snout

NORMAL DOG

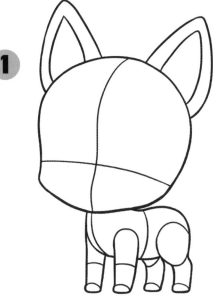

1

Draw the large head, and add horizontal and vertical guidelines. Draw the legs, along with guidelines indicating the joints. Note the small paws, which make the legs appear tapered.

2

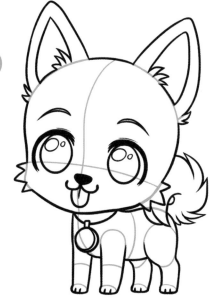

Add the eyes, exaggerating them to look meaningful. Simplify the mouth, and add a tongue. Draw small tufts of fur in select areas. Now draw two tiny lines on each paw to identify the toes. Then give the dog a small collar with an exaggerated dog tag.

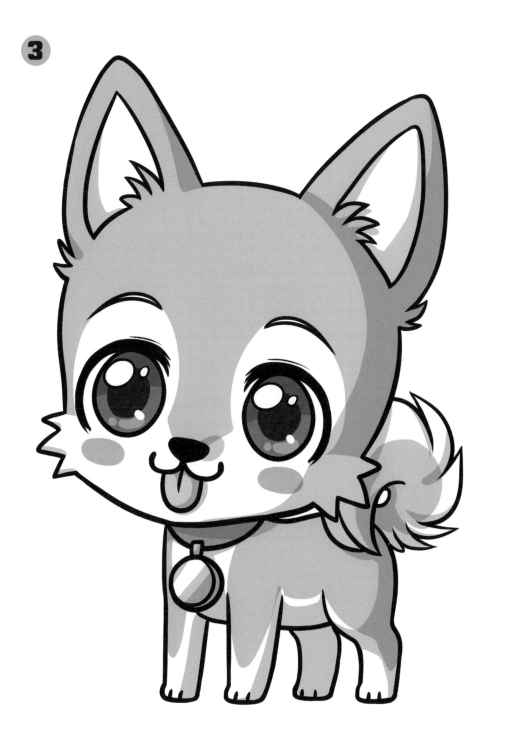

Add color and shading. Add highlights to the eyes and darken the pupils. Then add gleaming highlights to the dog tag for a metallic look. Lastly, add a blush to the cheeks.

Chibi Cat

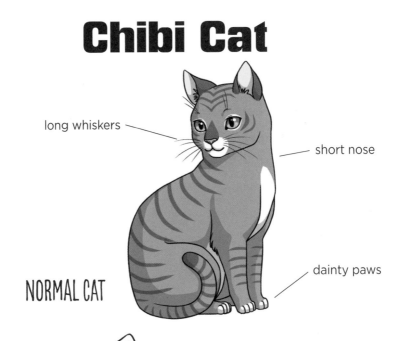

long whiskers

short nose

dainty paws

NORMAL CAT

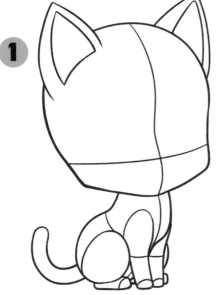

1

When drawing the body in a sitting position, maintain the arch of the back. Simplify the arms and legs, and add guidelines at the joints. The paws should look especially small and delicate. Make the tail shorter for a cartoonish effect.

2

Add the facial features, then add tufts of fur to the inside of the ears, on the cheeks, and on the chest to imply fluffiness. Next draw tiny lines to the front and back paws for the toes. Draw whiskers, and don't forget the collar and bell!

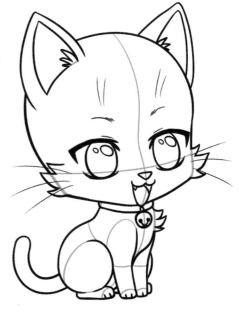

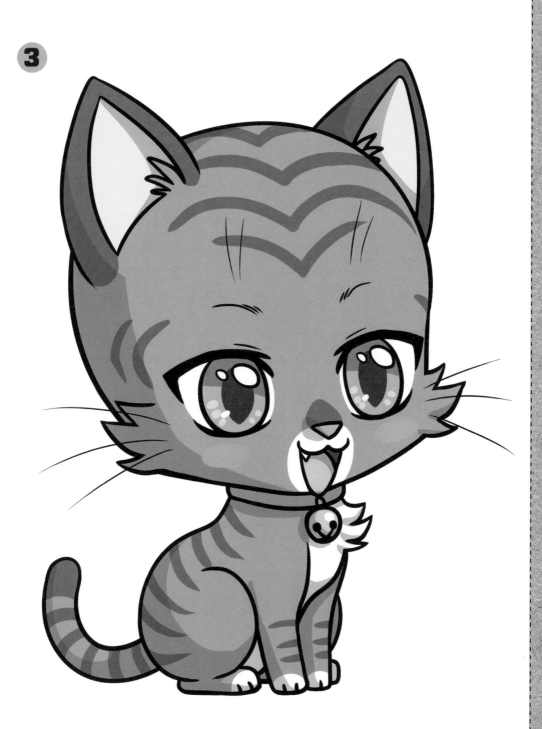

3

A feline's colors and patterns vary from cat to cat. Use color to indicate variations in pattern.

Chibi Bird

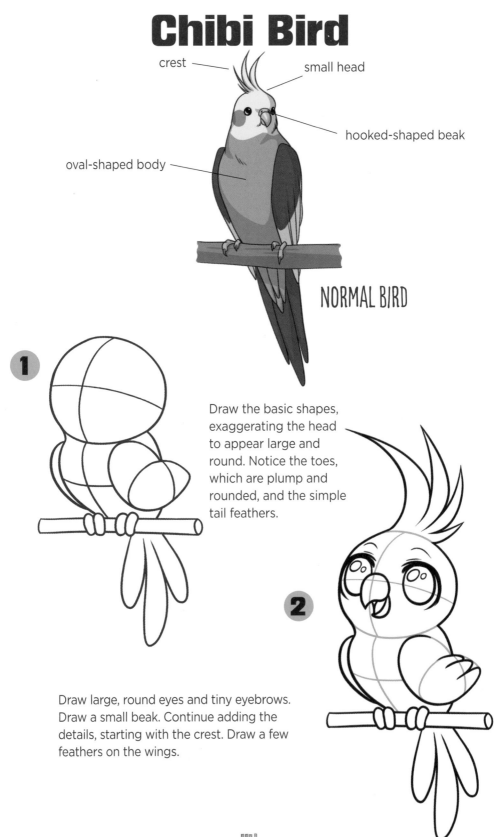

crest

small head

hooked-shaped beak

oval-shaped body

NORMAL BIRD

1

Draw the basic shapes, exaggerating the head to appear large and round. Notice the toes, which are plump and rounded, and the simple tail feathers.

2

Draw large, round eyes and tiny eyebrows. Draw a small beak. Continue adding the details, starting with the crest. Draw a few feathers on the wings.

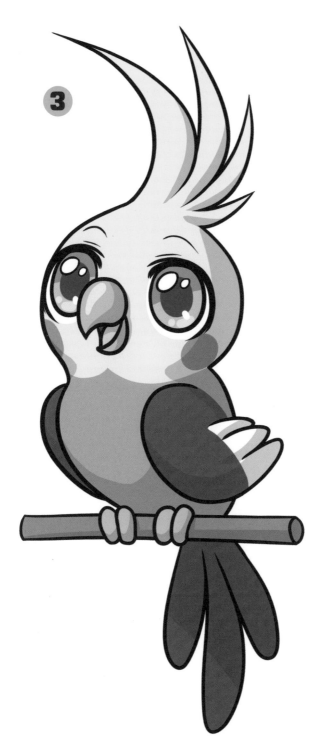

Establish your yellow, gray, and white colors. Designate a light source and shade the appropriate areas. Add darker pupils and highlights to the eyes.

Chibi Critter Combos

BUNNY-DOG-RACCOON

This silly critter has the body of a dog, the ears of a bunny, and the tail of a raccoon. He also walks on two legs, not four. Notice how his long ears match the shape of his tail and how lighter fur stripes accent both. He also sports an amber jewel on his forehead. Bright red eyes reflect his fun and fiery personality.

PURPLE PORCUPINE

A large dome-shaped body is this critter's most defining feature, followed by a row of dark purple quills on his back. Vibrant yellow emblems in interesting shapes add contrast to the fantasy-friendly purple tone. He also has a paddlelike beaver's tail and stubby flat feet. His spikes and strong tail indicate that this critter might specialize in defending others.

BIRD-DRAGON

This fantasy critter has the body of a dragon and the head, beak, and feathers of a parrot. Bright red scales makes him appear bold and exotic, and his googly eyes hint at a silly personality, despite his fierce colors.

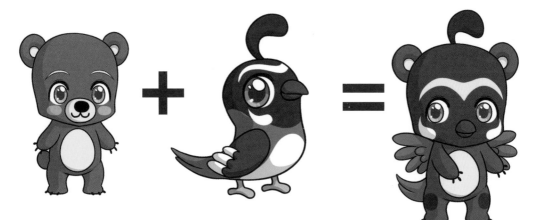

BEAR-QUAIL

Ever wonder what a bear-quail hybrid would look like? Wonder no more! Although our critter has the body shape, heavy fur, round ears, and strong limbs of a bear, it also has key quail features, such as a head plume and feather markings.

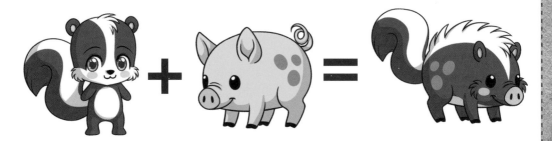

PIG-SKUNK

This critter has the chubby, oval body shape of a pig and the coloring, tail, and fur of a skunk. Little pink spots on the body, as well as rosy cheeks, give this fantastic creature even more charisma.

Chibi Fantasy Critter

This imaginary critter has rabbitlike attributes: big, fluffy ears; small front limbs; large hind legs; and long, flat feet. Draw the basic shapes for the head, body, limbs, ears, and tail. Use guidelines to identify the joints in the arms and legs.

Add the details, including tufts of fur on the forehead, cheeks, and tips of each ear. Add large circular eyes, a tiny nose, and a cute mouth. Add wings with curls on the back, and give him a long tail with a tuft of fur on the end.

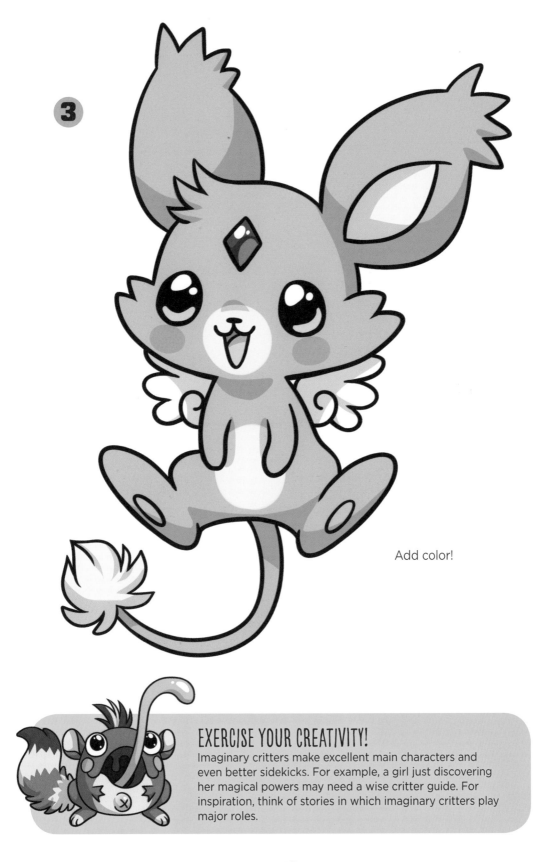

3

Add color!

EXERCISE YOUR CREATIVITY!
Imaginary critters make excellent main characters and even better sidekicks. For example, a girl just discovering her magical powers may need a wise critter guide. For inspiration, think of stories in which imaginary critters play major roles.

PRACTICE HERE

EXERCISE YOUR CREATIVITY!

When combining critters, start by choosing the basic body shape. Do you want your critter to be based mostly off one animal, or would you rather combine shapes from both? Then ask yourself the following questions:

1. How many legs does your critter have?
2. Does your critter fly? If so, does it use wings or does it float?
3. Does your critter have fur, scales, or fins?
4. What colors do you want your critter to be?

Chibi Scene

Now it's time to apply everything you've learned and draw a chibi scene. Start with basic shapes to plan your drawing. Then add one thing at a time.

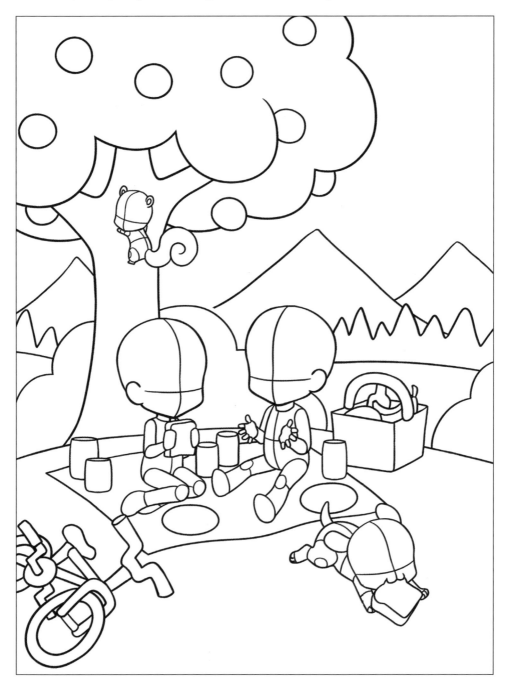

STEP ONE Start with basic shapes and guidelines.

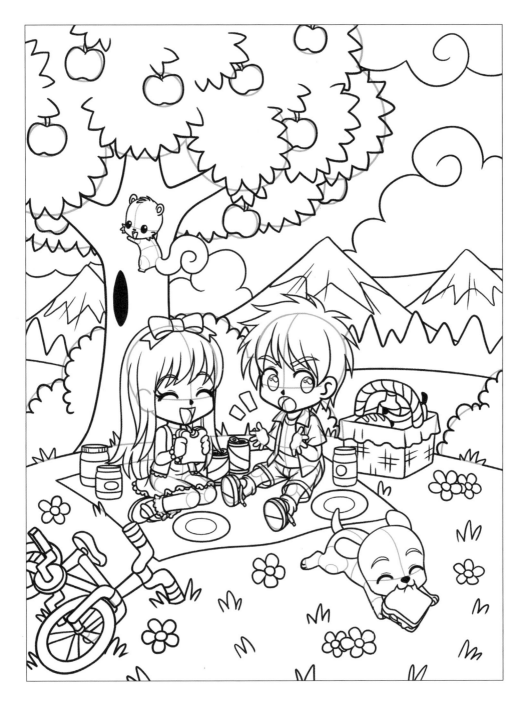

STEP TWO Now begin adding the details. Some artists work in "layers"—that is, they draw things that are closest to or overlap with what they drew first.

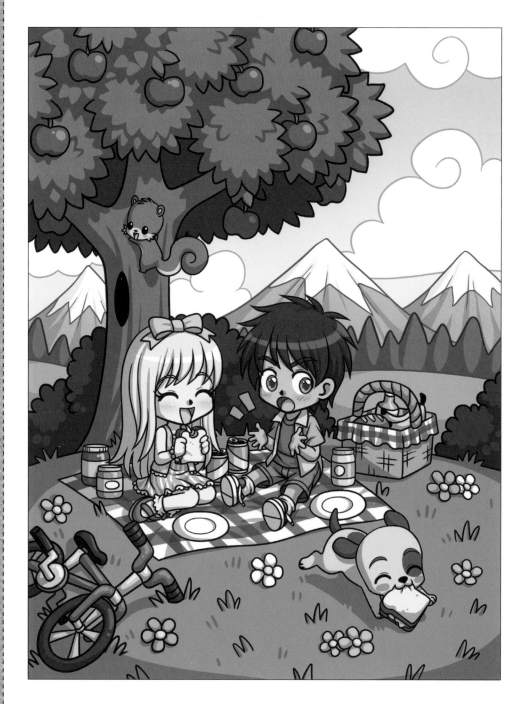

STEP THREE Now add color. Start by choosing your light source, which will define the placement of shadows. Simplification is still important. Far-off objects look faded and less detailed. Identify the main subject(s) of your image, and make them the focal point by clearly defining their details with color.

PRACTICE HERE

PRACTICE HERE